CitySpaces

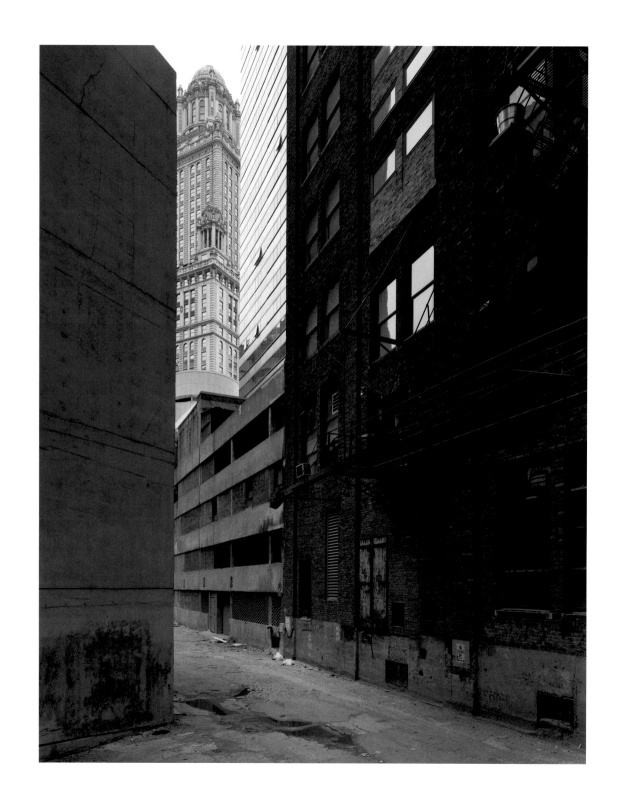

CitySpaces

PHOTOGRAPHS OF CHICAGO ALLEYS

Bob Thall

with an afterword by Ross Miller

The Center for American Places
Santa Fe, New Mexico, and Harrisonburg, Virginia

CENTER FOR
AMERICAN
PLACES

PUBLISHER'S NOTES

City Spaces: Photographs of Chicago Alleys is the third volume in the series *Center Books on Chicago and Environs*, created and directed by the Center for American Places. That series is supported in part by a grant from the Graham Foundation for Advanced Studies in the Fine Arts, for which the publisher is most grateful. This book was published in an edition of 2,000 clothbound copies with the generous financial assistance of Jeanne and Richard S. Press and Nancy and Ralph Segall, for which the publisher is also most grateful.

Previously published books in the series are *The City in a Garden: A Photographic History of Chicago's Parks* (2001) by Julia Sniderman Bachrach, in association with the Chicago Park District, and *A Natural History of the Chicago Region* (2002) by Joel Greenberg, in association with the University of Chicago Press.

The photograph by Art Sinsabaugh on page 5 appears courtesy of the Art Sinsabaugh Archive at the Indiana University Art Museum in Bloomington (© Elisabeth Sinsabaugh de la Cova and Katherine Sinsabaugh; reproduction photograph by Michael Cavanagh and Kevin Montague); the photograph by Thomas Annan on page 7 appears courtesy of the LaSalle Bank Photography Collection, Chicago; and the photograph by Eugene Atget on page 8 appears courtesy of a private collection in Chicago.

THE CENTER FOR AMERICAN PLACES, INC.
P.O. Box 23225
Santa Fe, New Mexico 87502, U.S.A.
www.americanplaces.org

Distributed by the University of Chicago Press
1427 East 60th Street
Chicago, Illinois 60637-2954, U.S.A.
www.press.uchicago.edu
Book orders: 800-621-2736
Information: 773-702-7700
9 8 7 6 5 4 3 2 1

Library of Congress Cataloging-in-Publication Data:
Thall, Bob.
 City spaces: photographs of Chicago alleys/Bob Thall; with an afterword by Ross Miller.
 p. cm.—(Center books on Chicago and environs)
 ISBN 1-930066-07-4 (alk. paper)
 1. Street photography—Illinois—Chicago. 2. Alleys—Illinois—Chicago—Pictorial works.
 I. Miller, Ross. II. Title. III. Series.

TR659.8.T49 2002
779'. 4773'11—dc21 2002073878

For more information about the Center for American Places and the publication of *City Spaces: Photographs of Chicago Alleys*, please see page 86.

CONTENTS

ACKNOWLEDGMENTS

I am deeply grateful to many people for the support and advice that made this book possible. A Fellowship from the John Simon Guggenheim Memorial Foundation gave me the rare gift of months of uninterrupted time to begin this set of work and to do most of these photographs. The publication of *City Spaces* was made possible by the tremendously generous support of Jeanne and Richard S. Press and Nancy and Ralph Segall. Their quick commitment to the project at a crucial moment made all the difference.

The central contributor in all three of my book projects has been George F. Thompson, president of the Center for American Places. I admire George's commitment to publishing books of serious photography, books that really are about American places. His dedication, hard work, intelligence, and boldness have given my work a public life it would not have had without his interest and support. I've come to depend on his judgment and friendship.

As I began these photographs, several close friends gave me early moral support and helpful critiques. I'm particularly grateful to Jocelyn Nevel, Melissa Pinney, Denise Miller, and Peter Hales. Carol Ehlers was enthusiastic about these pictures at an early stage, and showed them in a wonderfully designed exhibit at her much-missed Chicago gallery. As I was assembling this book, many people advised me on the editing and sequence. Particularly insightful were my colleagues in the Columbia College Photography Department, especially Alan Cohen and Paul D'Amato. As I worked on the book mock-up, my friends in the Columbia College Digital Lab were very patient. I'm especially grateful to Tammy Mercure, Tom Shirley, Thomas Wolfe, and others. Becky Boehner helped with the early stages of darkroom work. I'm grateful to Randall B. Jones at the Center for American Places for his diverse efforts, to Garnett Kilberg Cohen, of Chicago, for her sound editorial advice, and to David Skolkin, of Santa Fe, for his sensitive design.

Ross Miller's insights into the history and fabric of the Chicago landscape have been an important source for my work. Better than anyone I know, he reads the surfaces of this city for clues to its complicated social history. I'm delighted that he contributed an afterword to this book. The LaSalle Bank of Chicago, the Indiana University Art Museum, and a private collector in Chicago were kind to allow the reproduction of images from their collections. I'm also grateful to Carol

Ehlers, Scott Dietrich, Garry Henderson, Nan Brewer, and Kathy Taylor for their assistance.

For twenty-six years my photographic work has benefited from the support of Columbia College Chicago. I'd like to thank John Mulvany, the former Chair of the Photography Department; Dr. Warrick Carter, President; Bert Gall, Executive Vice-President; Steven Kapelke, Provost; and Leonard Lehrer, Dean of Fine and Performing Arts.

CitySpaces

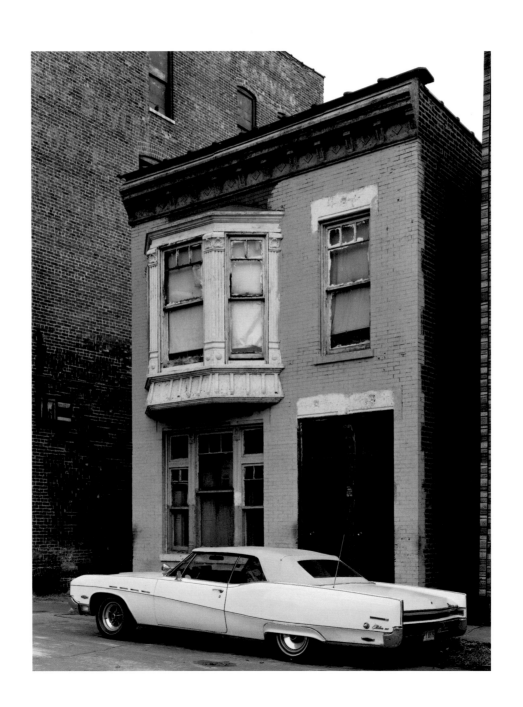

Bob Thall, Near North Side
neighborhood, Chicago, 1973.

I studied architecture for a while in college, before I discovered photography. My friends and I were night owls. We would often study and work on our drawings until 1 or 2 in the morning and then get together to drink coffee and eat burgers on the far north side of Chicago. After an hour in some diner we'd pile into one of the big American cars our fathers owned and drive aimlessly around, talking and looking at the city. We'd critique neighborhood architecture and remodeled houses. Sometimes we would play an improvisational game, pointing out a house that seemed resonant and imagining details within:"That's an old bachelor's place—he's rebuilding a carburetor on the kitchen table"; or "A grandmother, I'd say, with lace doilies on the arms of all the chairs." The trick was to notice some small clue and then extrapolate wildly. After a few years I drifted out of architecture into photography and forgot, for a while, about the game of imagining lives from the facades of houses.

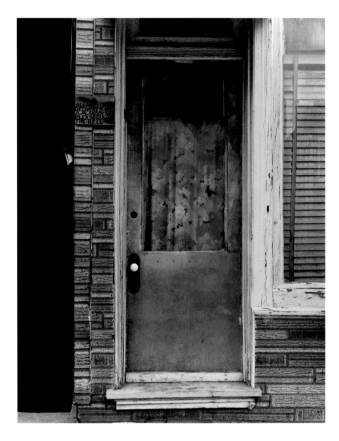

Bob Thall, Pilsen neighborhood,
Chicago, 1973.

It would be difficult to explain the photographs in this book without a little history. My history, the history of photography, and most importantly the recent history of Chicago.

I was born in Chicago in 1948 and going downtown in the late 1950s and early 1960s was an adventure. It was an exciting place to explore. My favorite places were the observation deck at the top of the Prudential Building, then the tallest building in Chicago at about 50 stories (as shown in Art Sinsabaugh's *Chicago Landscape #292*), and, equally engrossing, the Illinois Central terminal buried beneath the street just below. Big, mysterious, slightly sinister, the train station contained a number of hot dog and pizza stands, juice bars, exotic magazine displays, and an excellent pinball arcade. After I had emptied my pockets into the machines I might visit the Art Institute and the Public Library, both nearby. Mostly, though, I just roamed around downtown, looking at things.

My earliest serious photographs were done about 1969 in the style of my first heroes: Henri Cartier-Bresson and Robert Frank. I had become a photography major at the University of Illinois at Chicago, and although I was excited about photography I was still a bit ambivalent about my earlier experience in the architecture program. In 1971 I decided to make photographs of altered and distressed buildings that would, I thought, critique the pretensions of architects. I borrowed a view camera and roamed around some old neighborhoods in Chicago, especially Pilsen, where I could find a lot of ornate old structures showing the scars

of hard use and poverty. Luckily, I quickly lost interest in purely architectural issues, and instead remembered our old game of reading the surfaces of buildings for clues to the history of the inhabitants. I was fascinated and began what is now a thirty-year project of photographing the city's landscapes in and around Chicago.

In 1994 I published *The Perfect City*, which described the changes to downtown Chicago over a twenty-year period. When I began photographing downtown Chicago in the early 1970s it was a very gritty, authentic-feeling place. Chicago's central landscape had been frozen by the Depression. No new major downtown buildings were started from 1930 to 1954. Downtown in the 1970s was still a bit seedy and grim. The surfaces had a dark patina. It was diverse, complicated, and old. The city felt very real.

During the 1980s a building boom transformed the downtown landscape, replacing many small, old structures with huge new office buildings. The maze of unique street-level shops disappeared, replaced by sanitized lobbies and national chain businesses. The last ten years have brought other fundamental changes. The city has been aestheticized. Flower boxes are in the middle of many streets. Charming "retro" lampposts replaced many of the 1950s streetlights. Downtown Chicago is increasingly a place designed for tourists. Described as a "festival" landscape, this change is producing a city-as-theme-park. The theme, of course, is a fictitious and nostalgic concept of Chicago. The wonderful way

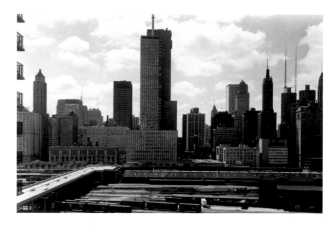

Art Sinsabaugh, *Chicago Landscape #292*, from "Chicago Landscape Group," 1966.

that a city can truthfully contain and reveal its own history has been diminished. Much of downtown Chicago no longer feels like a real place.

In 1996 as I was completing my second book, *The New American Village*, I chanced on a scene on the near west side and casually took a picture, using the last sheet of unexposed film I had with me. That photograph (page 39) intrigued me. It didn't fit in with anything I was planning to work on. I couldn't really decide if it was even a good picture, but I couldn't dismiss it either. In 1998 I was ready to start a new body of work. I had planned to photograph the industrial area of southeast Chicago, but that odd picture of an alley stuck in my mind. I thought that I would listen to the advice I give my students: don't plan too much, just follow up on interesting pictures.

What I found as I systematically explored downtown alleys were the remnants of the old city I had once found so compelling. The fronts of these buildings may have been extensively refurbished but no one had bothered with the back. One could see the evidence of many years of use and history. These alleys are deep urban slits, the walls twenty, thirty, or forty stories tall. Rain almost never hits the sides directly. Signs, marks, and layers of paint survive, fading slowly. The rat control crews leave the dates of their poison drops on the walls, and some chalk marks survive five or ten years.

The alleys weren't easy spaces to photograph. Over the course of a year, I needed to concentrate on the most basic elements of photography: light, space,

framing, and very small changes in vantage point. I felt that I had returned to my beginnings as a photographer and was forced to rediscover the elements of the medium that I had long ago struggled to control. The dim light in these places required long exposures, vulnerable to vibrations from traffic and the El trains, but I learned to see the delicate and lovely quality of light in small spaces lit by tiny rectangles of sky way above me. The visual delights of the city and architecture never seem more important than when they are found in unexpected circumstances. Prompting one to see beauty and significance where it's not anticipated is one of the most important gifts of photography.

Working with a view camera attracts attention and curiosity. The truck drivers, maintenance people, and homeless who are in these alleys would ask me what I was doing. Looking for a simple, easy explanation I would tell them that I admired photographs that Eugene Atget had done of the Paris alleys more than sixty years earlier. I said that I thought I'd try the same thing here in Chicago. That seemed to satisfy the questioners, and some of them, surprisingly, even knew of Atget's work. They had seen the photographs I was talking about at the Art Institute or the LaSalle Bank.

I had thought of Atget's photographs as an easy explanation, but I soon started to think seriously of those and other early photographs of cities and walls. I looked at Thomas Annan's photographs of the narrow streets of Glasgow and photographs of the monuments of the Middle East done soon after the invention

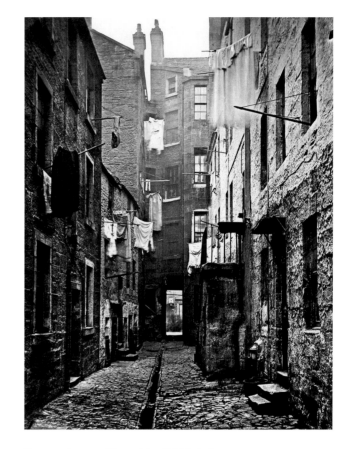

Thomas Annan, *Close, No. 75 High Street*, Glasgow, Scotland, published circa 1878.

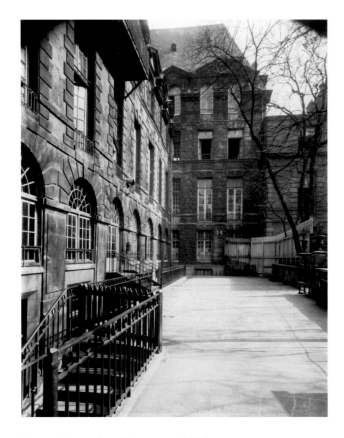

Eugene Atget, *Cour*, Paris, circa 1910.

of photography by Salzmann and others. Until this moment in my career, referring consciously to the work of other photographers would have seemed to me unambitious. I saw the post-modern quotes in the work of other photographers as a sort of defeatism, an acknowledgment that one can't compete with the earlier masters on their terms. Now, I was surprised to feel differently. I had to admit that having published two books and having recently won a Guggenheim Fellowship made me feel that I had earned a very small place in the history of photography. I flattered myself with the thought that the earlier photographers were now colleagues and the many small similarities to their work I saw in my photographs seemed a type of collaboration.

Smelly, dirty, dark, and occasionally a bit dangerous, working in these alleys was not physically pleasant. At the end of the block I could often see people in shorts walking in the sunshine across the alley toward Grant Park and Lake Michigan. I felt submerged in a dark, murky pool, and emerging out of an alley after an hour of timing long exposures could feel like rising to the surface. Still, this project was one of the most exciting and wonderful experiences I've had as a photographer. Investigating these spaces reminded me of my earlier sense of the city as a mysterious landscape to explore. My history as a Chicagoan, my history as a photographer, the history of the city, and, in a small way, the history of photography—without any plan or anticipation, these photographs brought these histories together for me.

Chicago Alleys

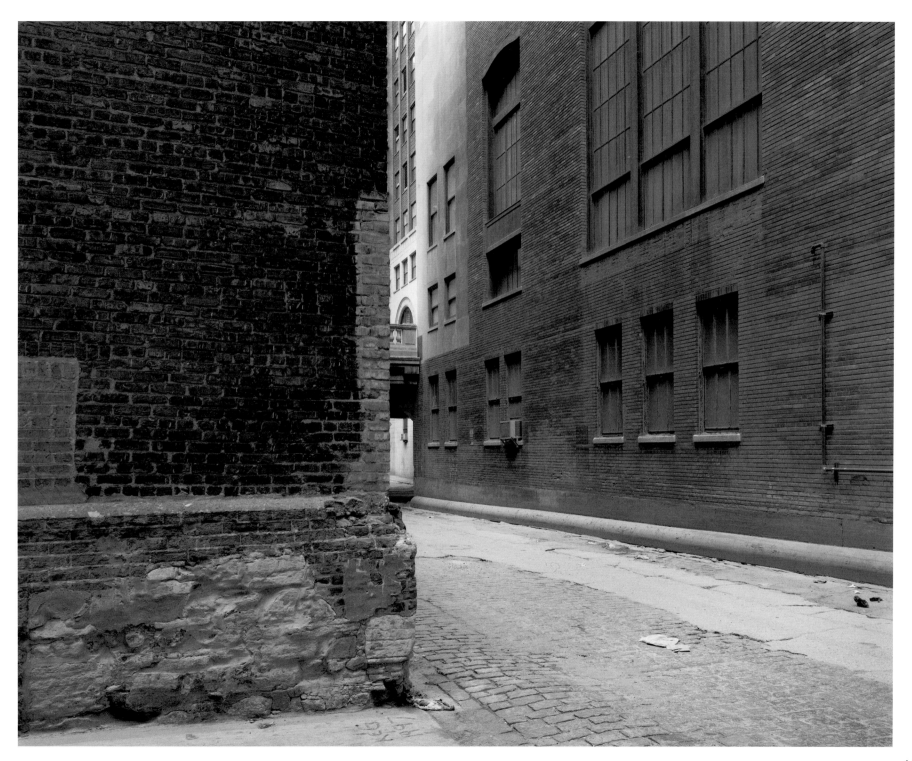

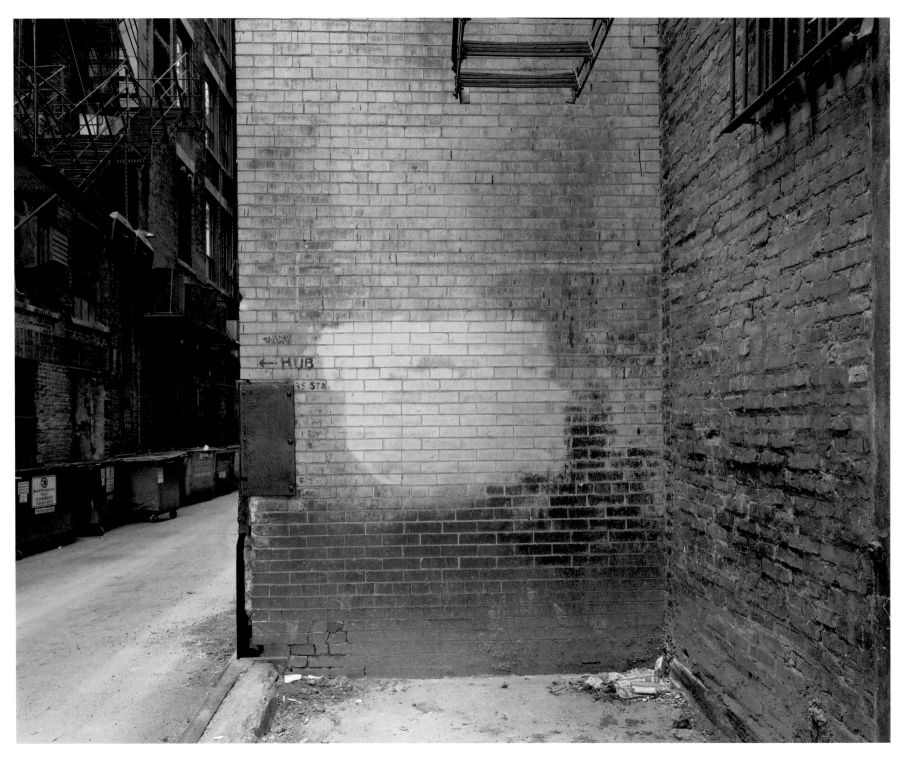

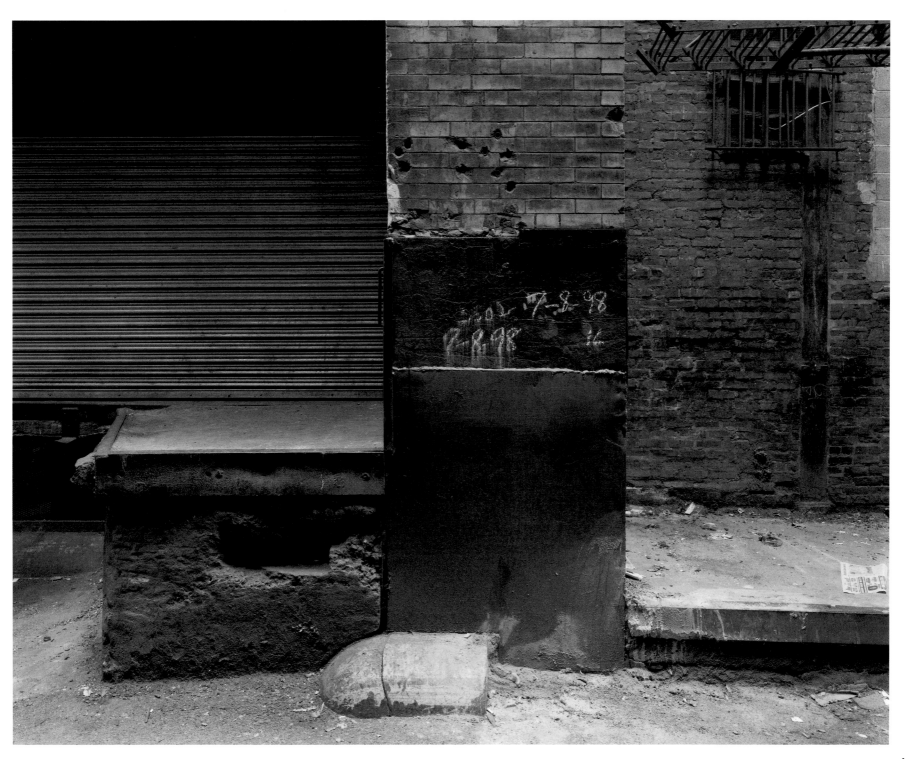

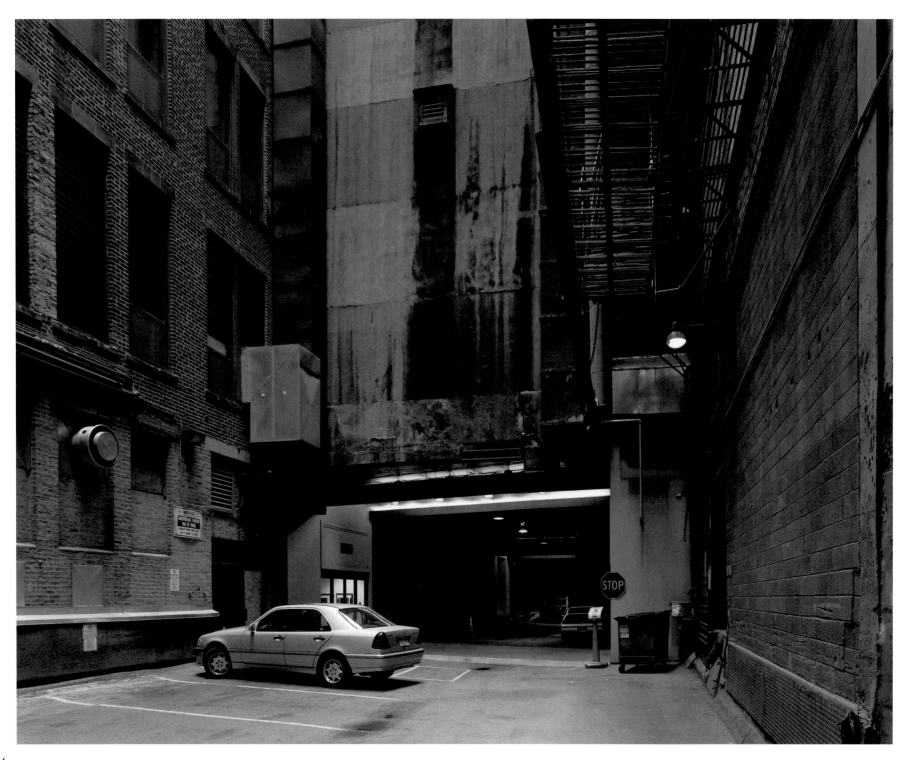

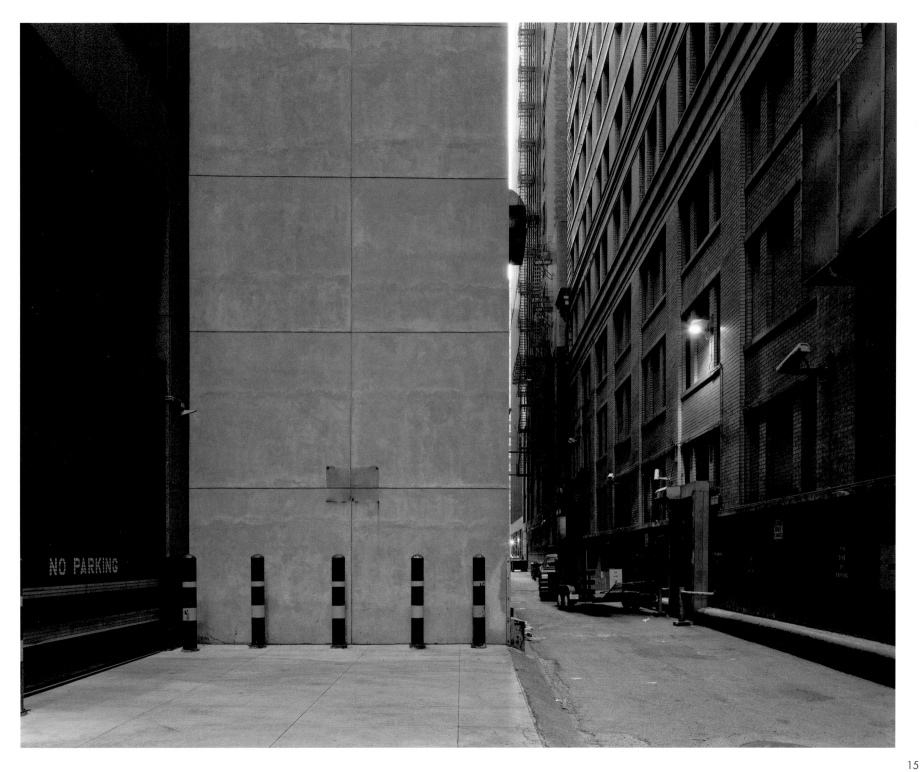

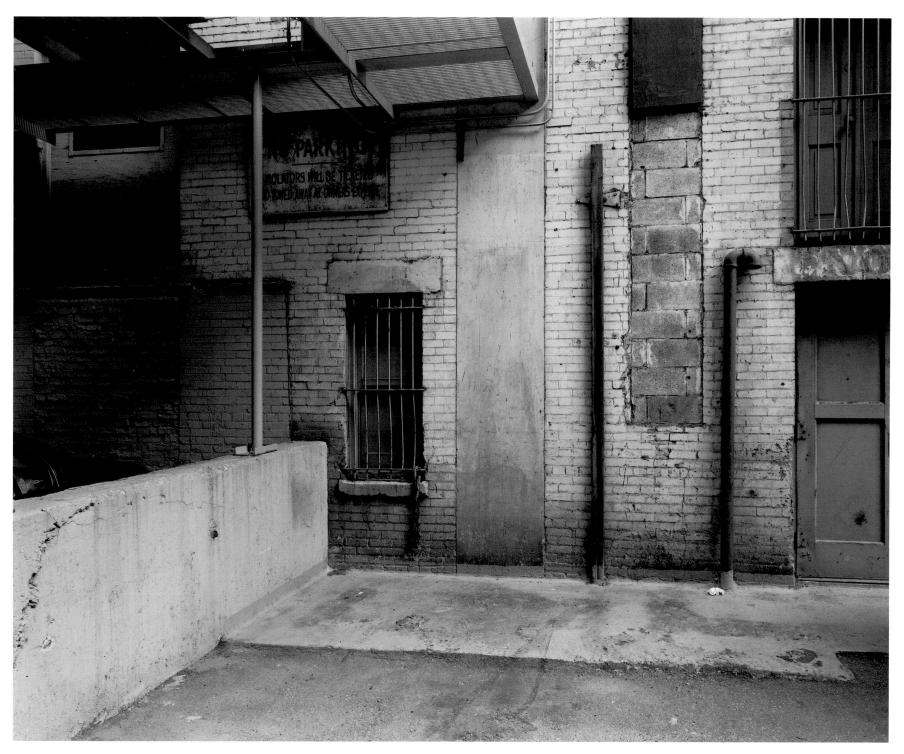

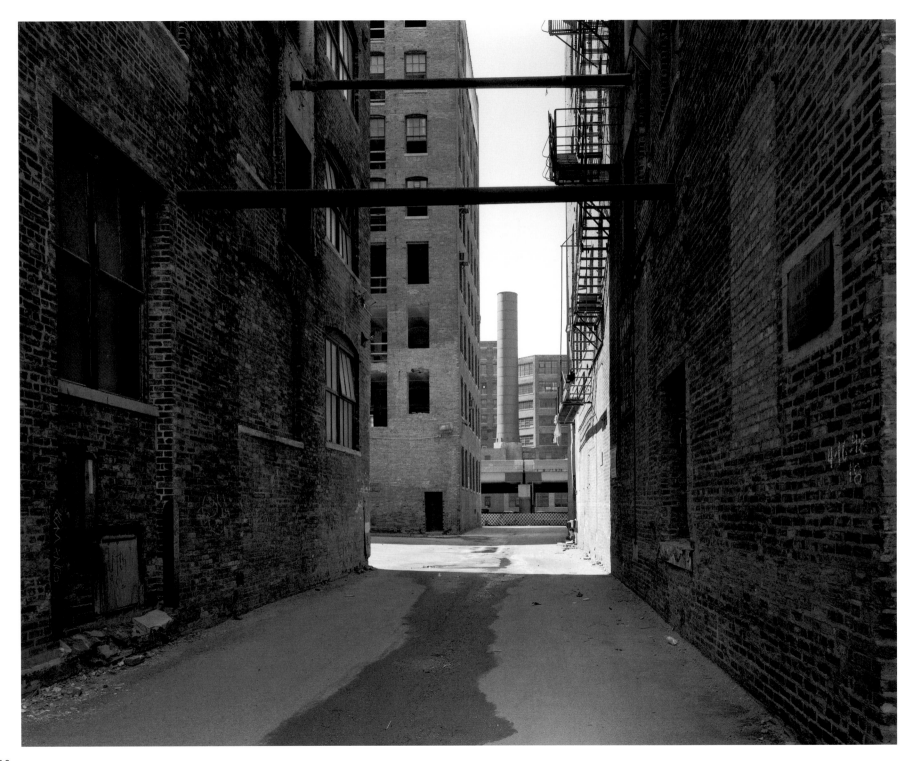

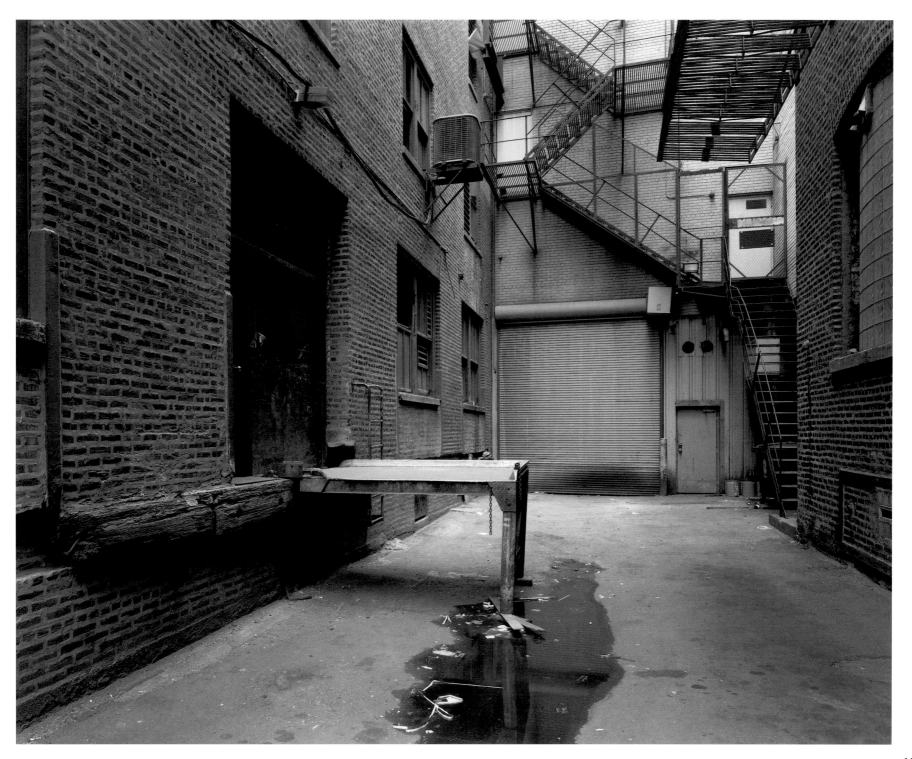

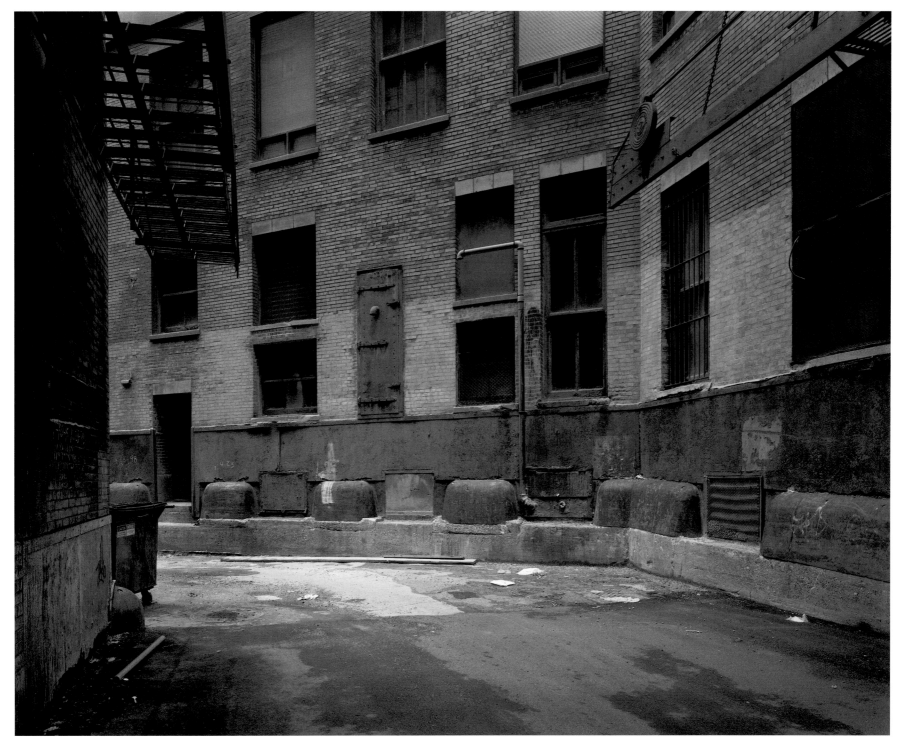

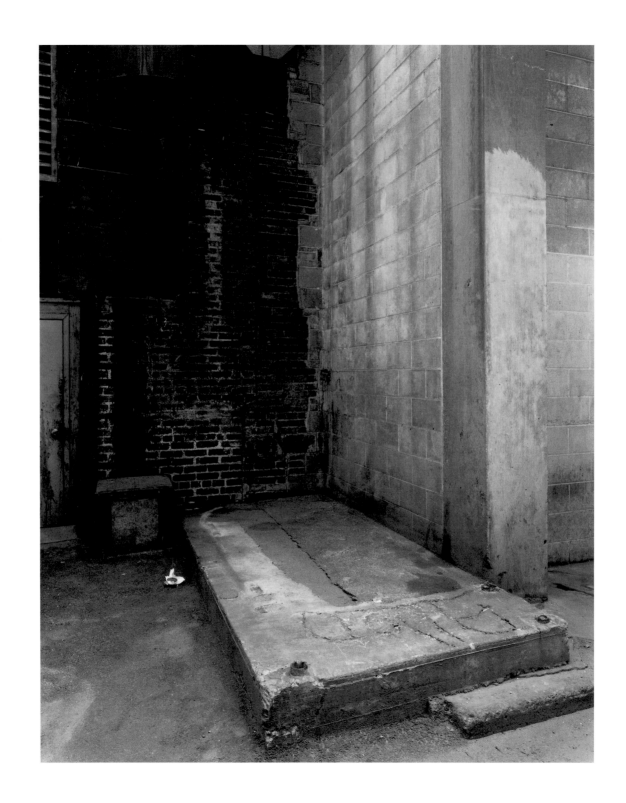

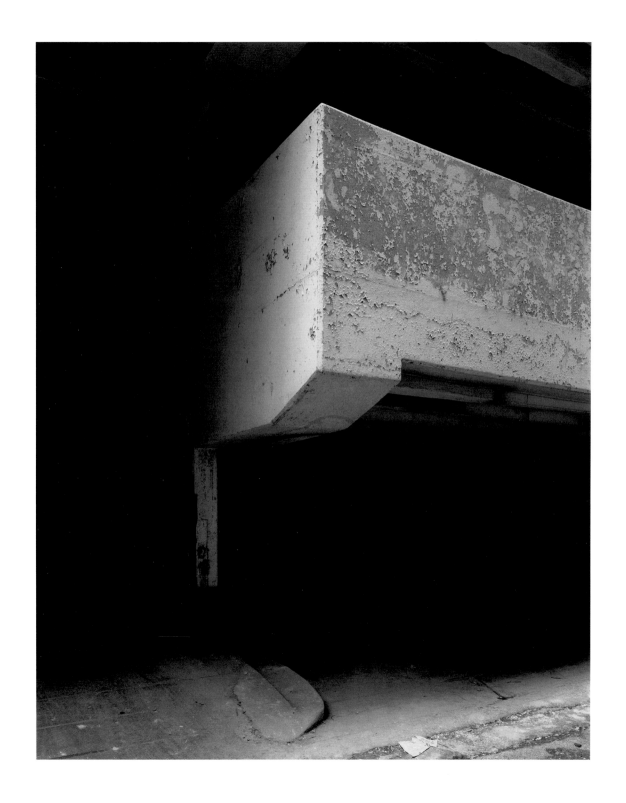

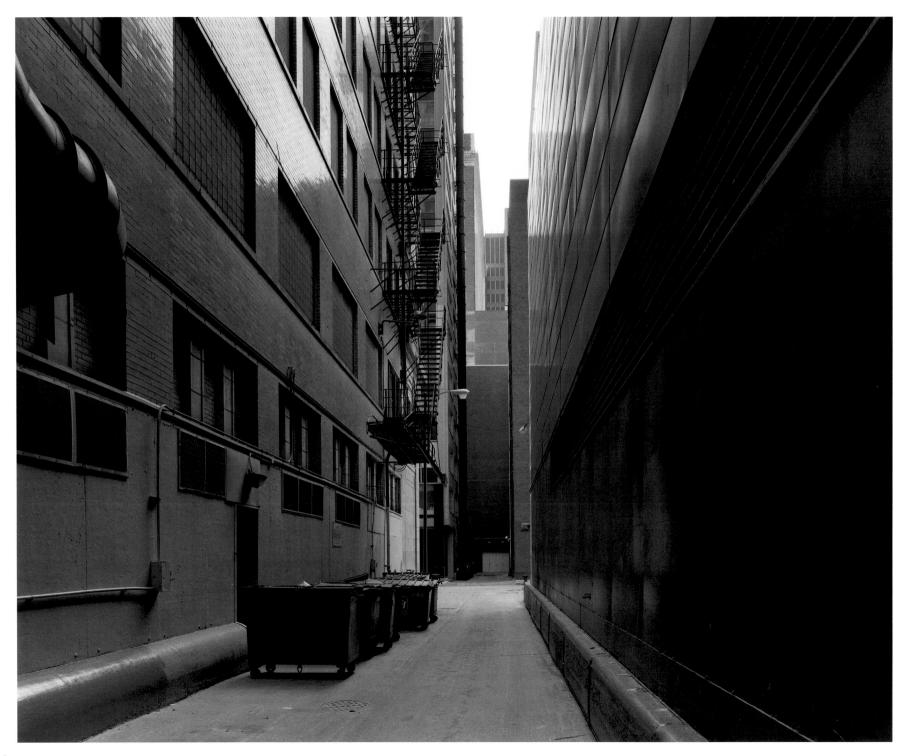

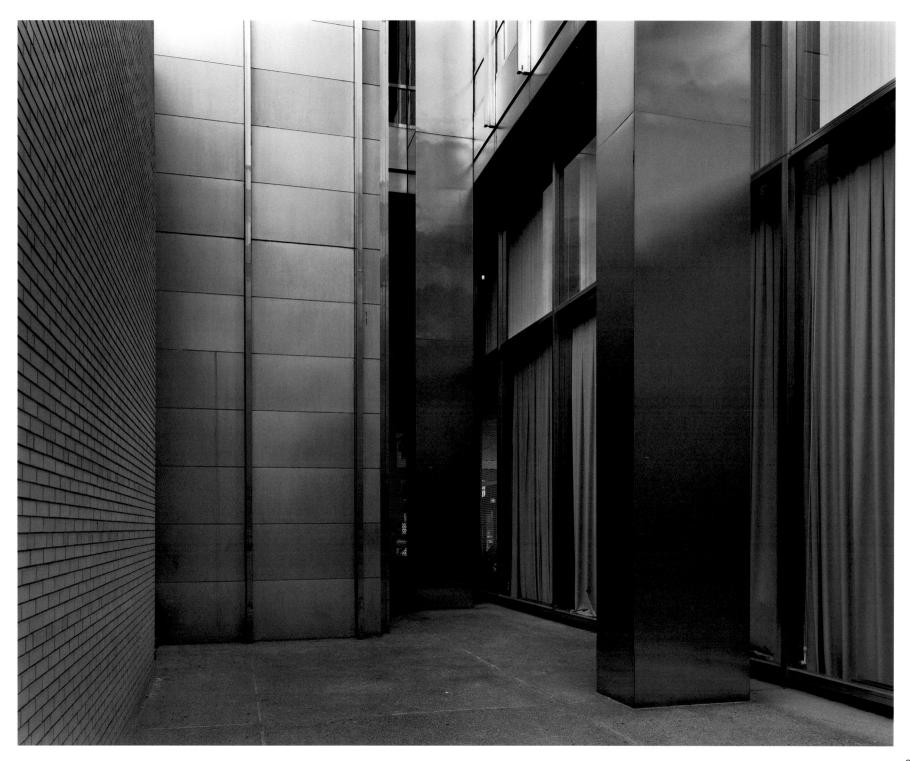

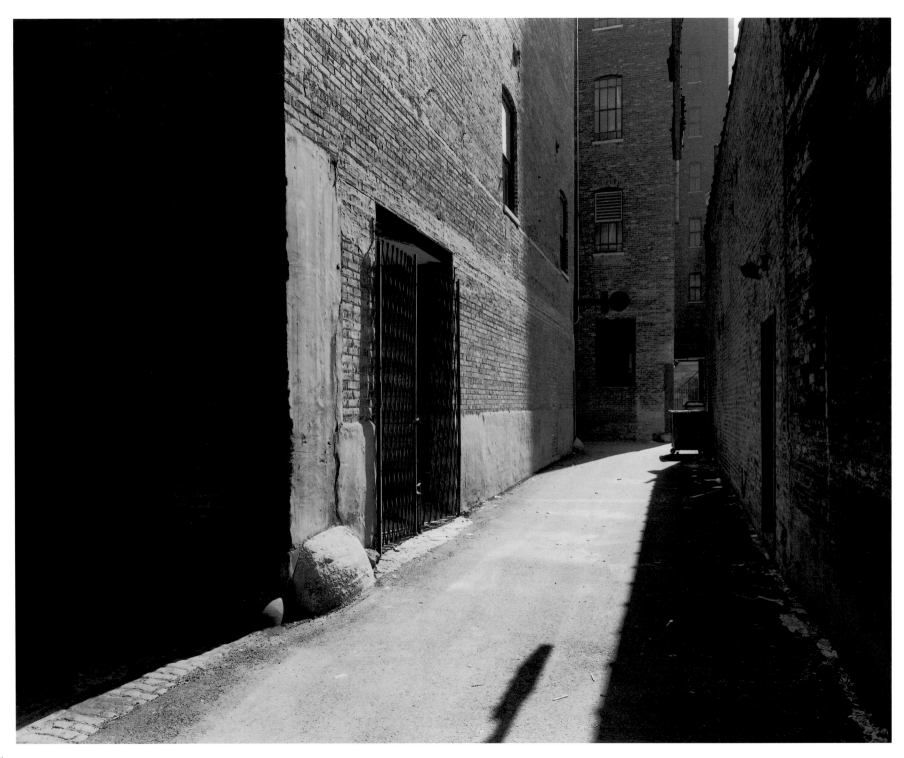

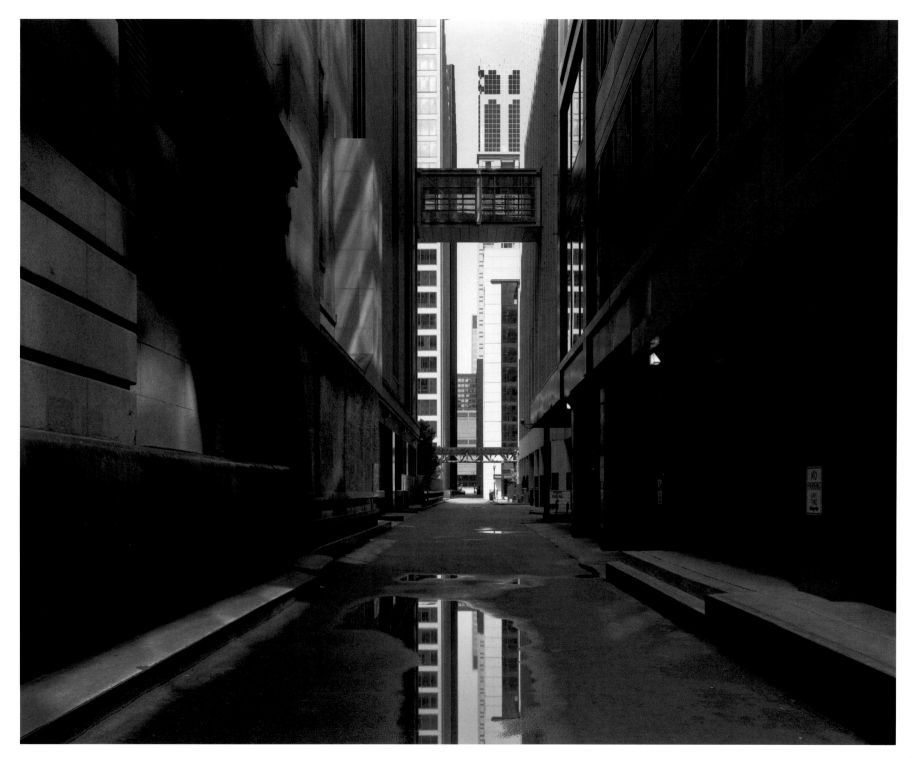

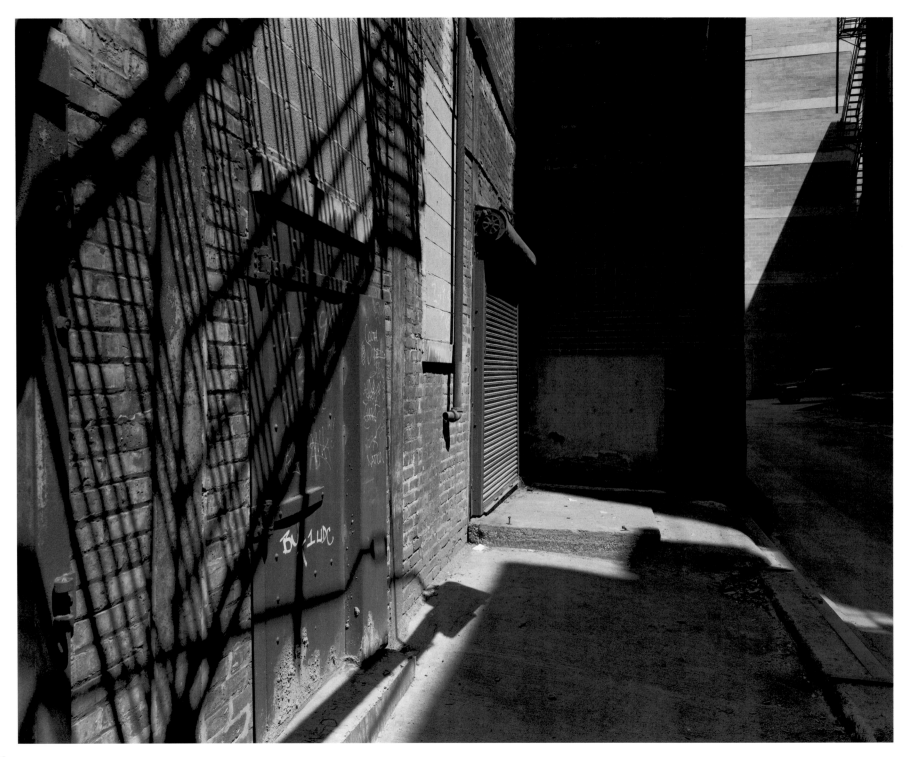

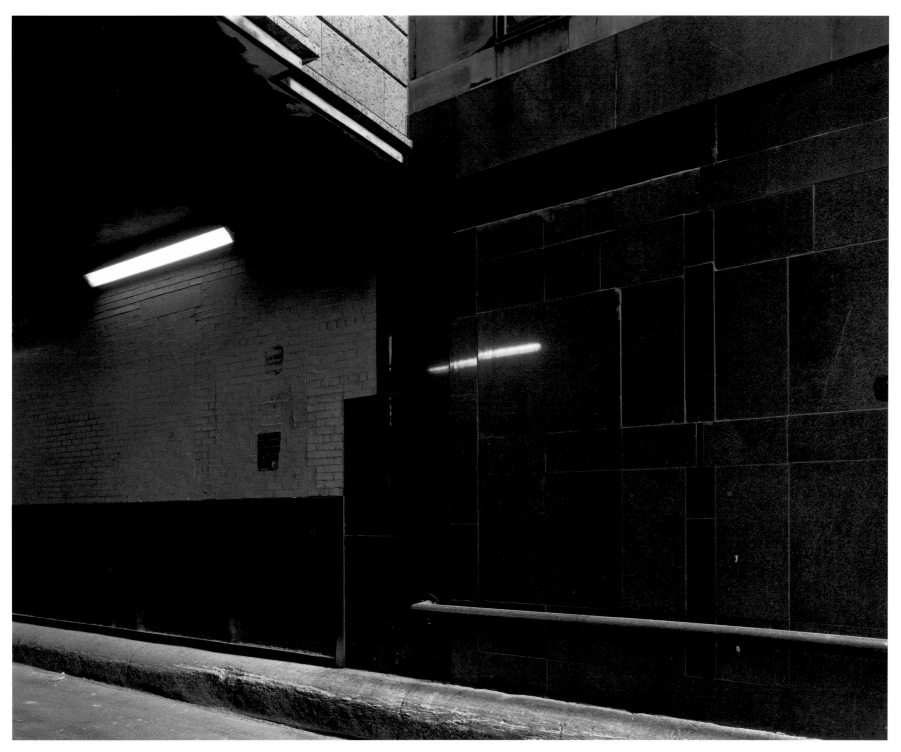

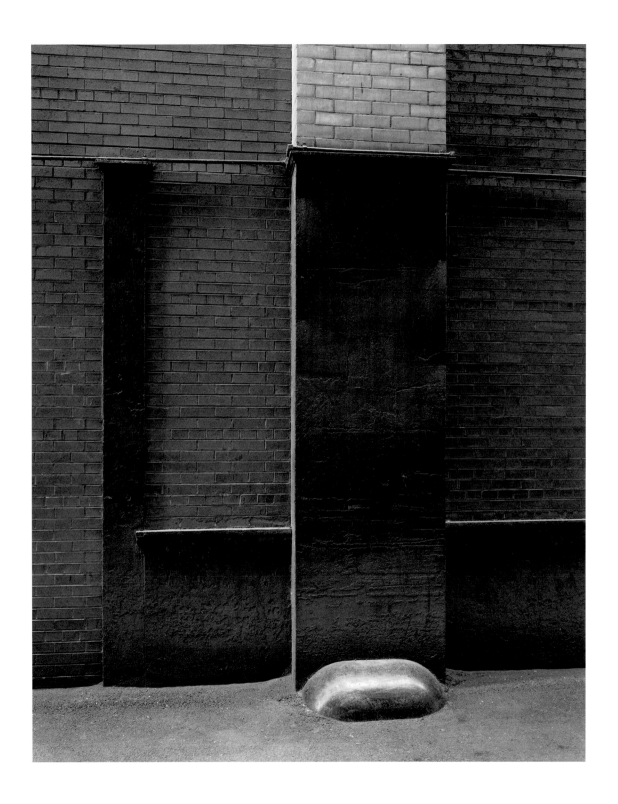

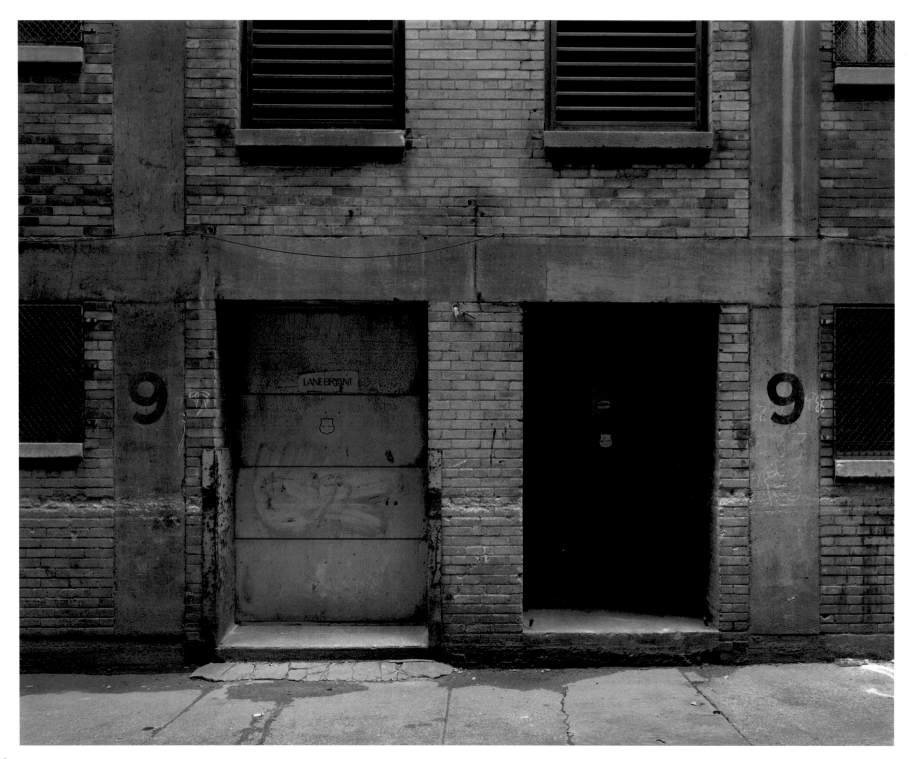

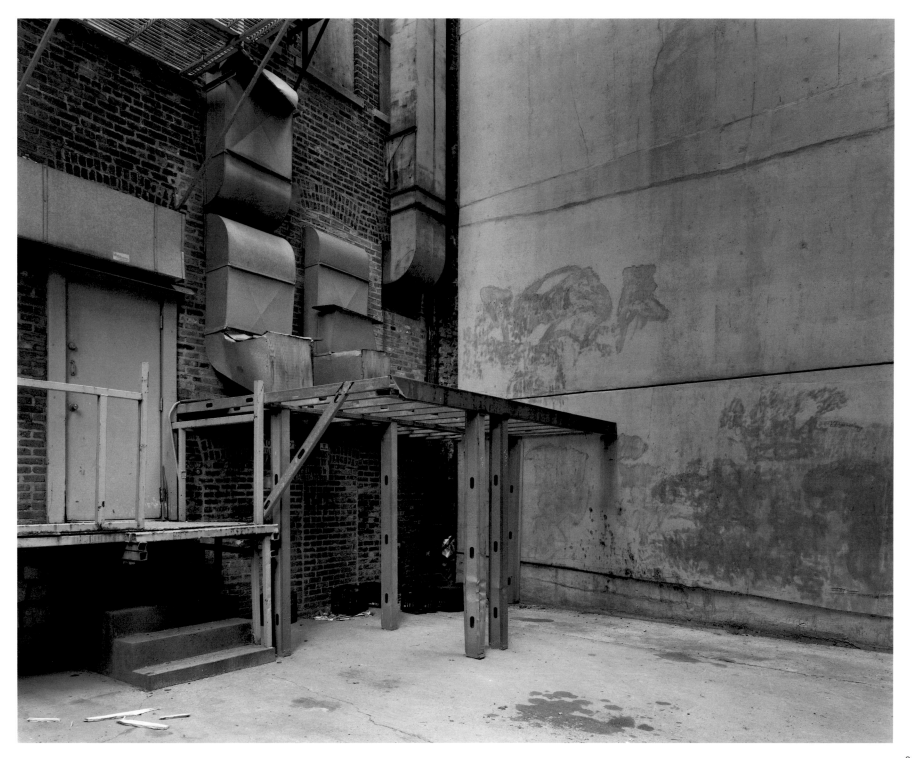

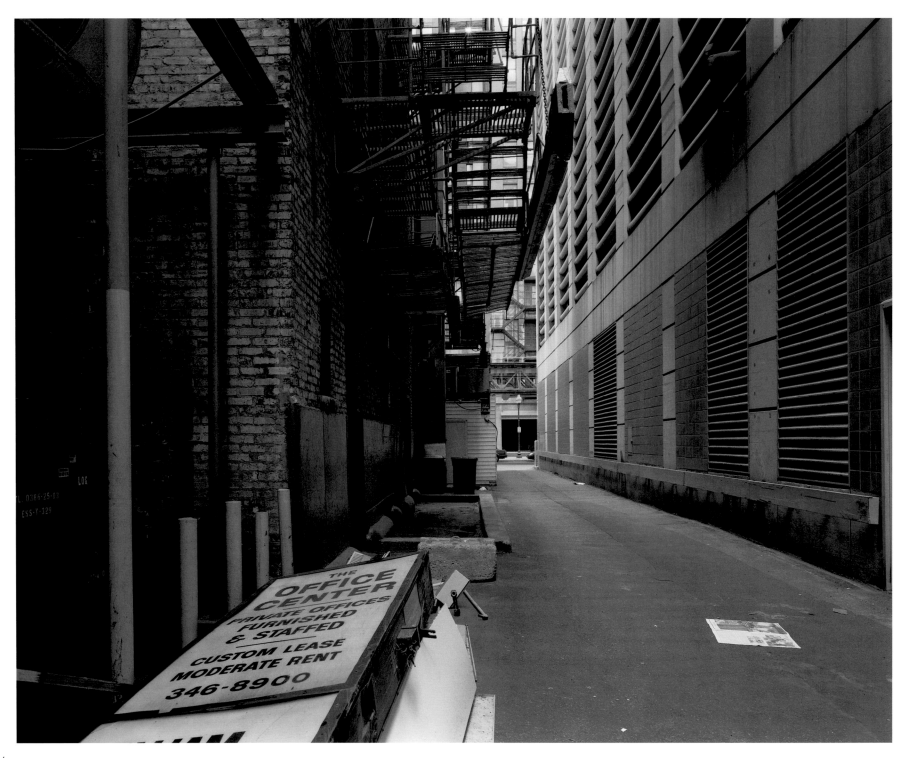

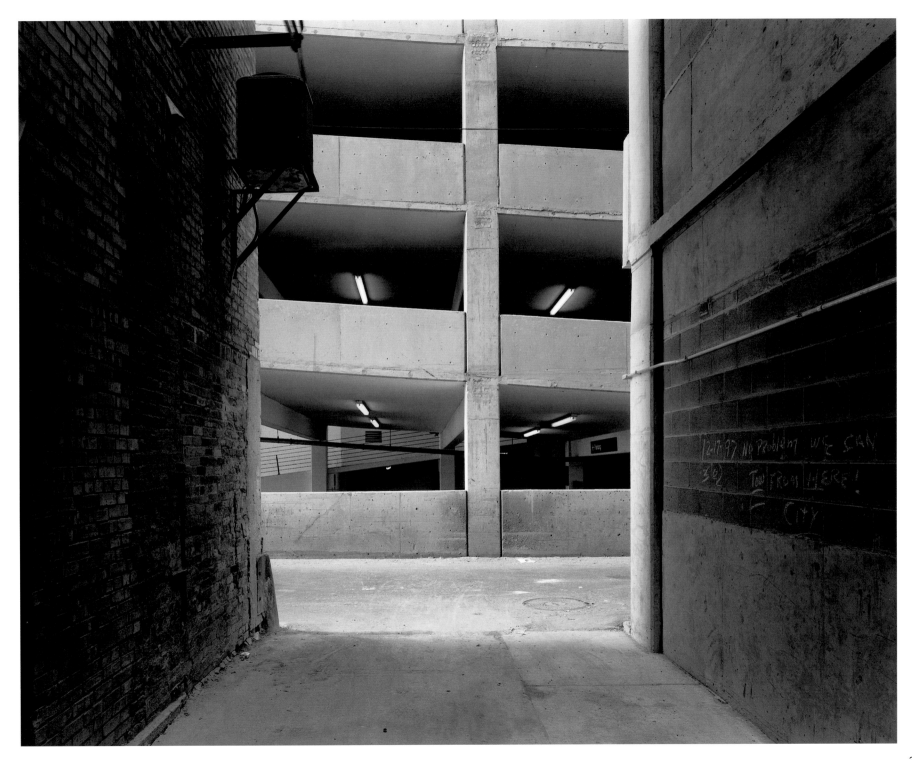

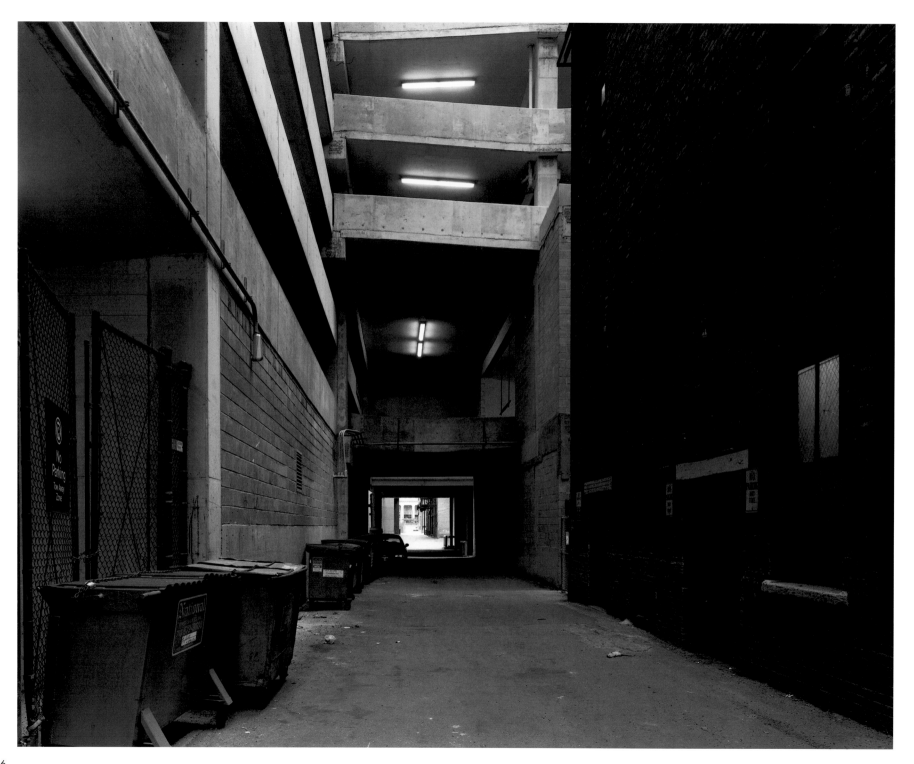

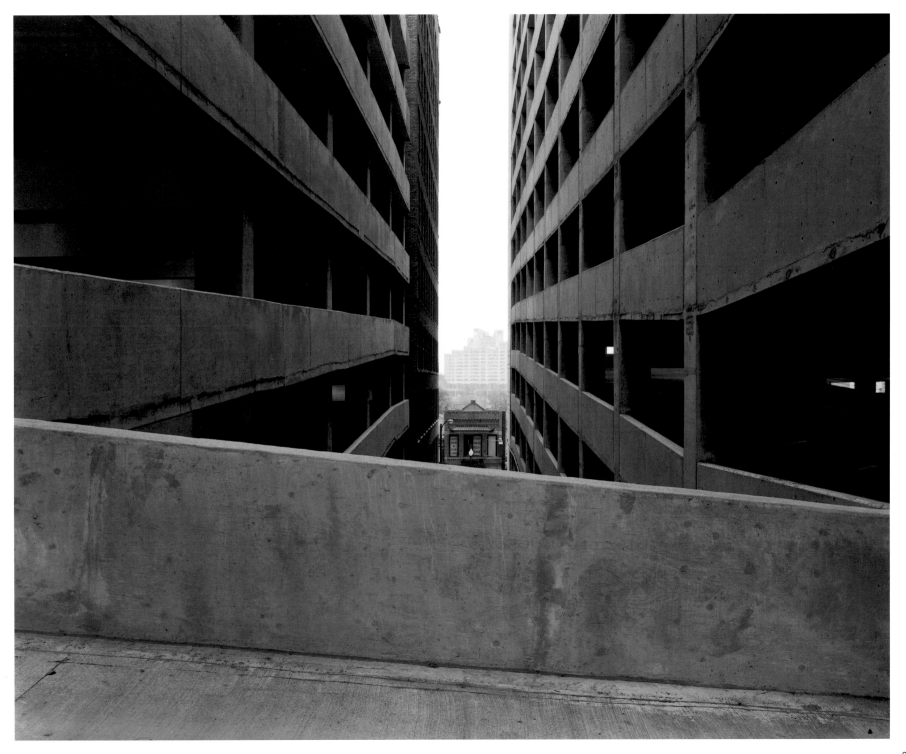

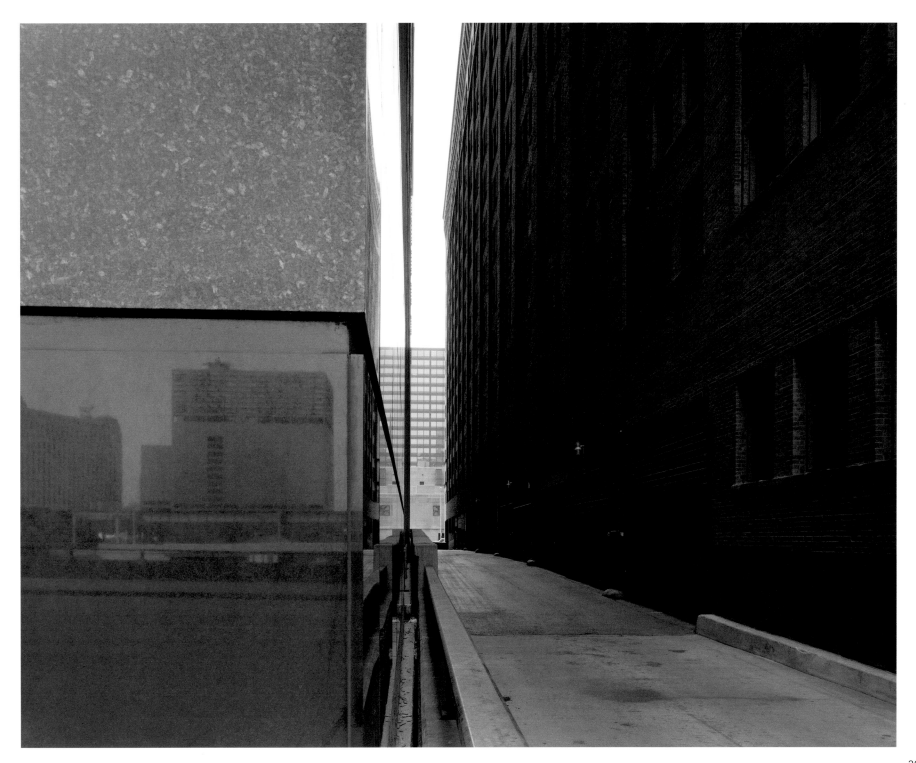

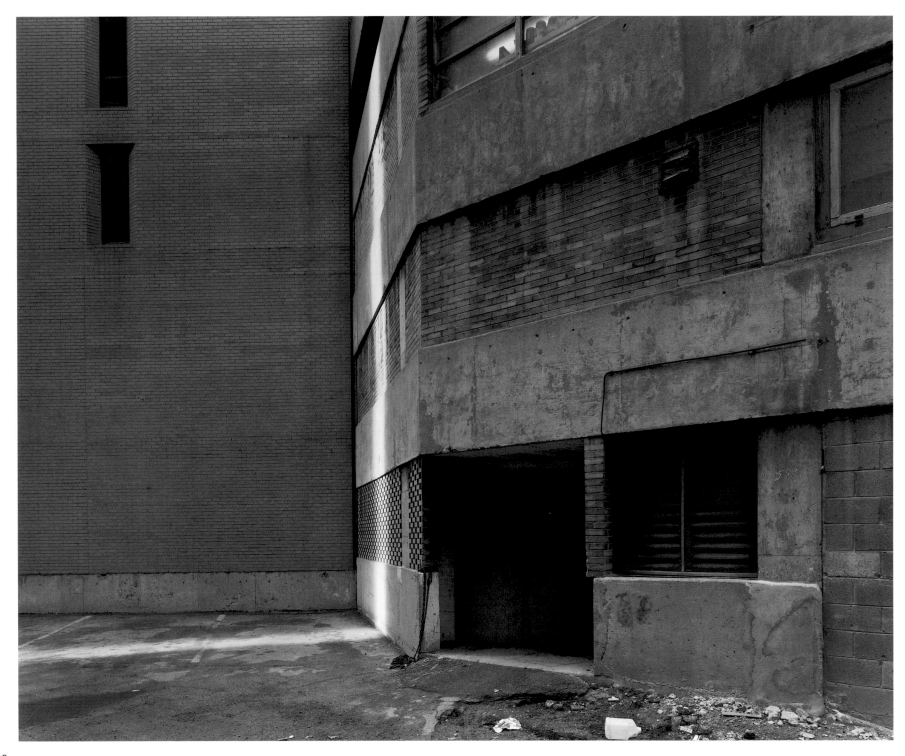

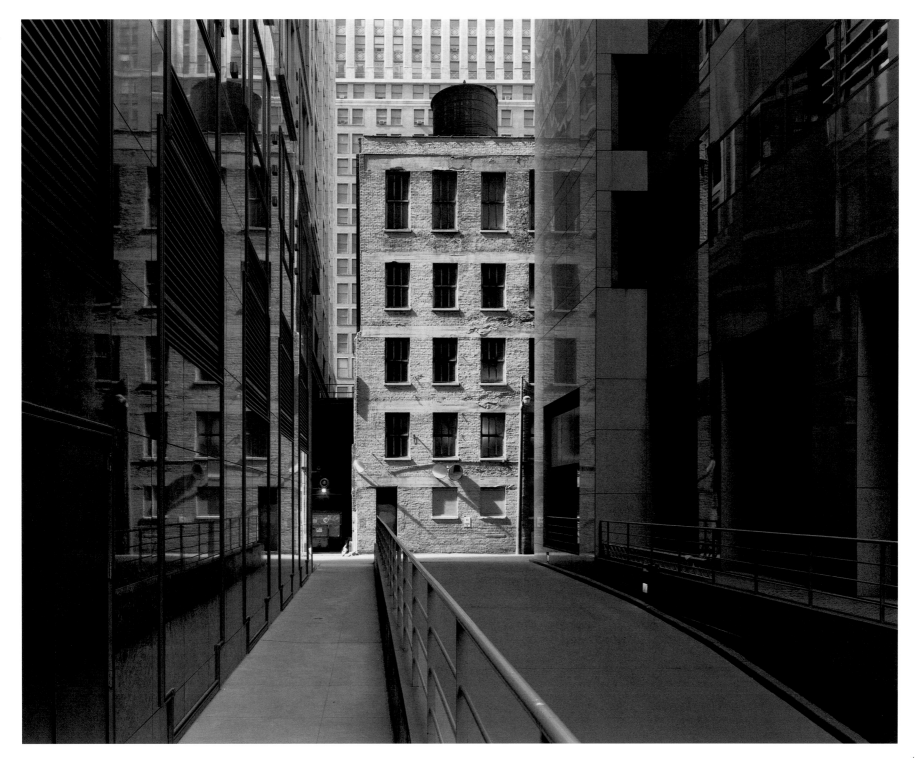

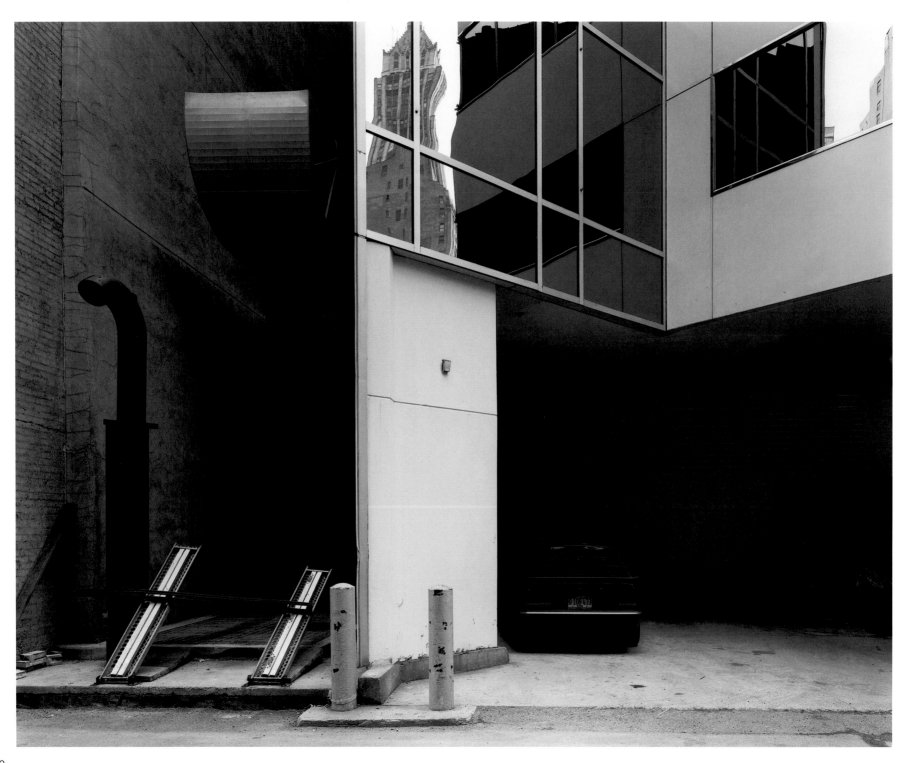

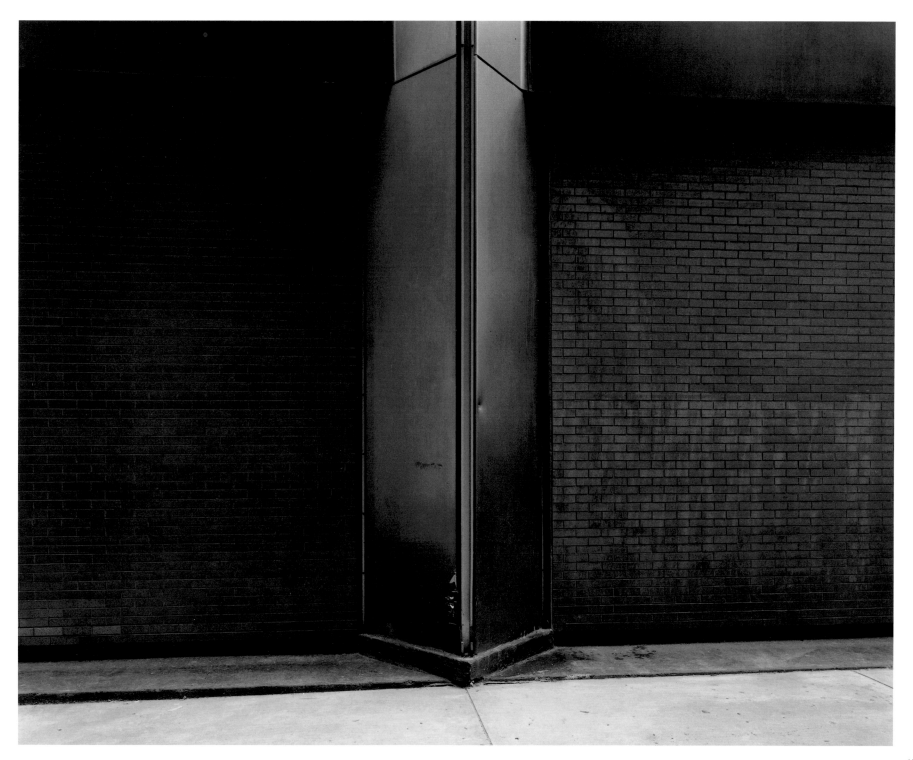

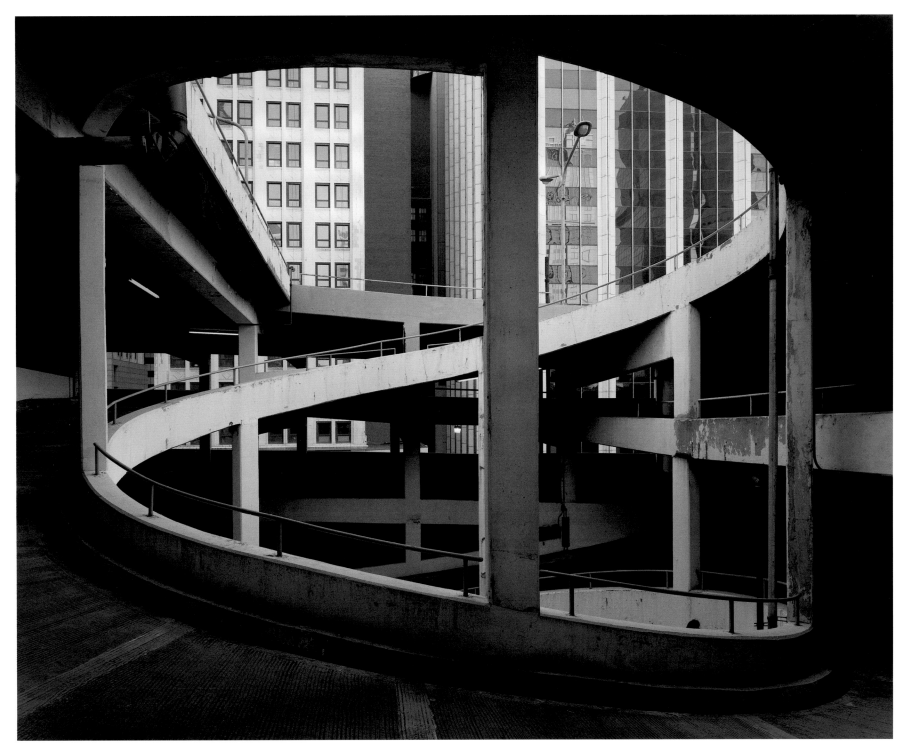

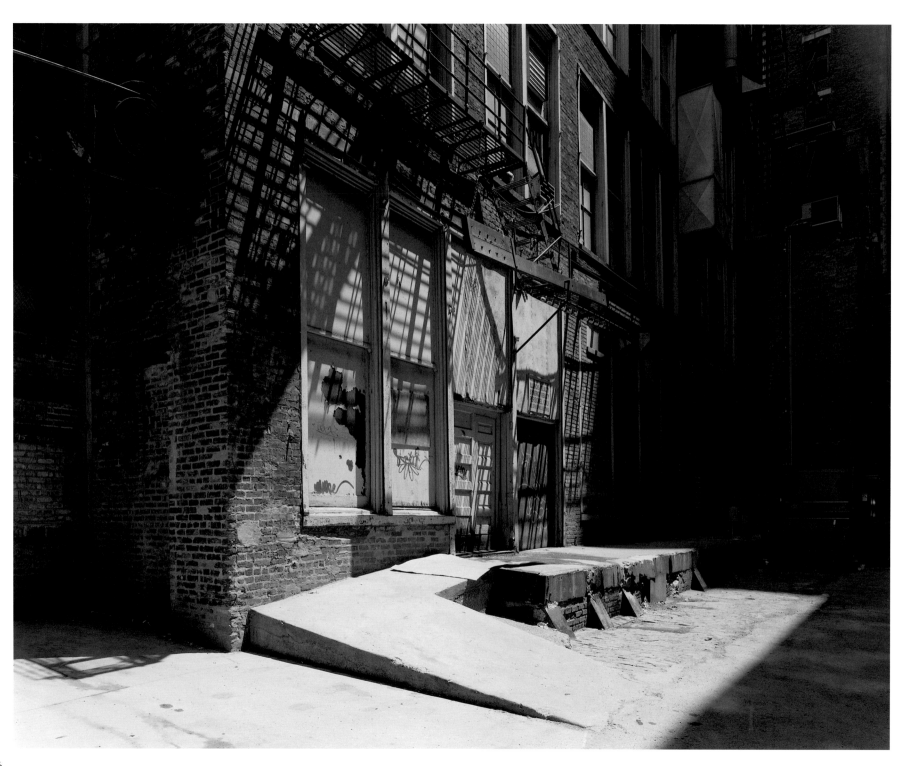

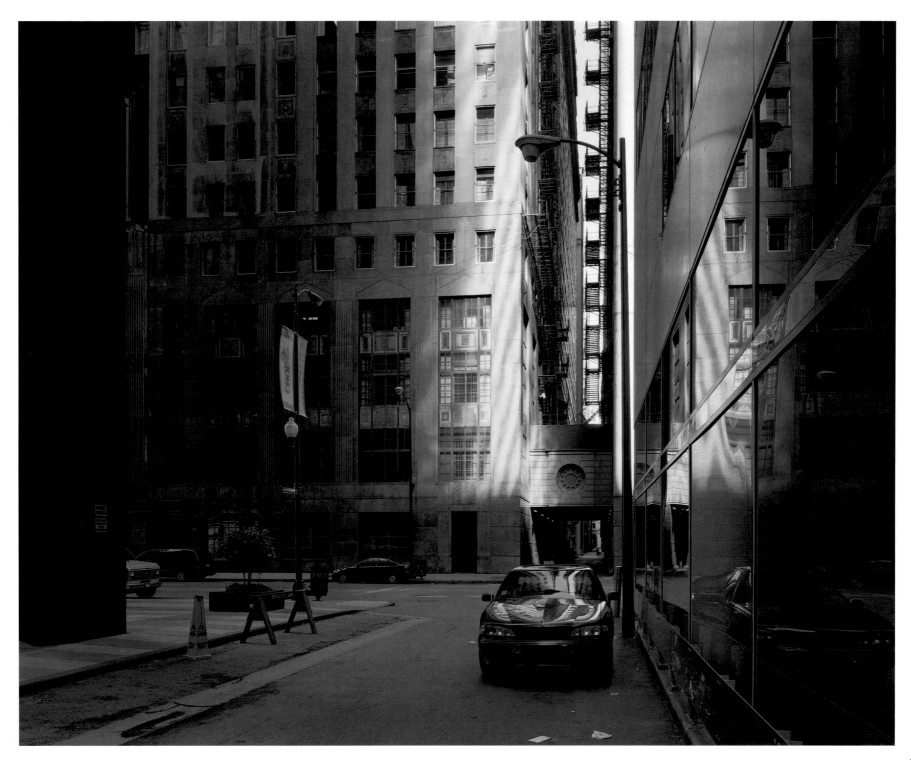

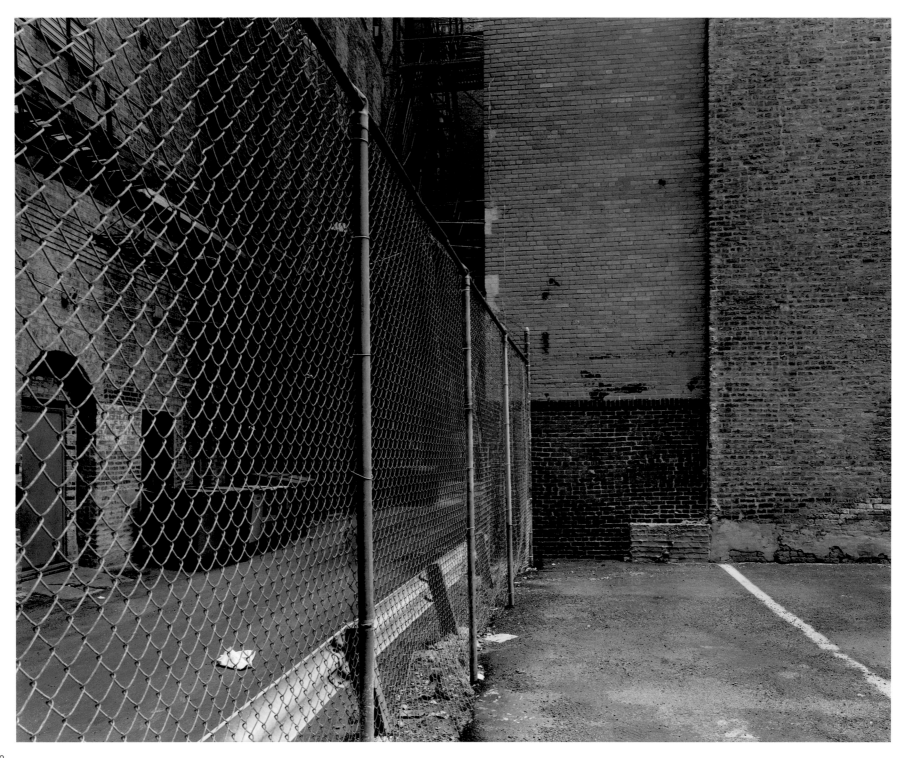

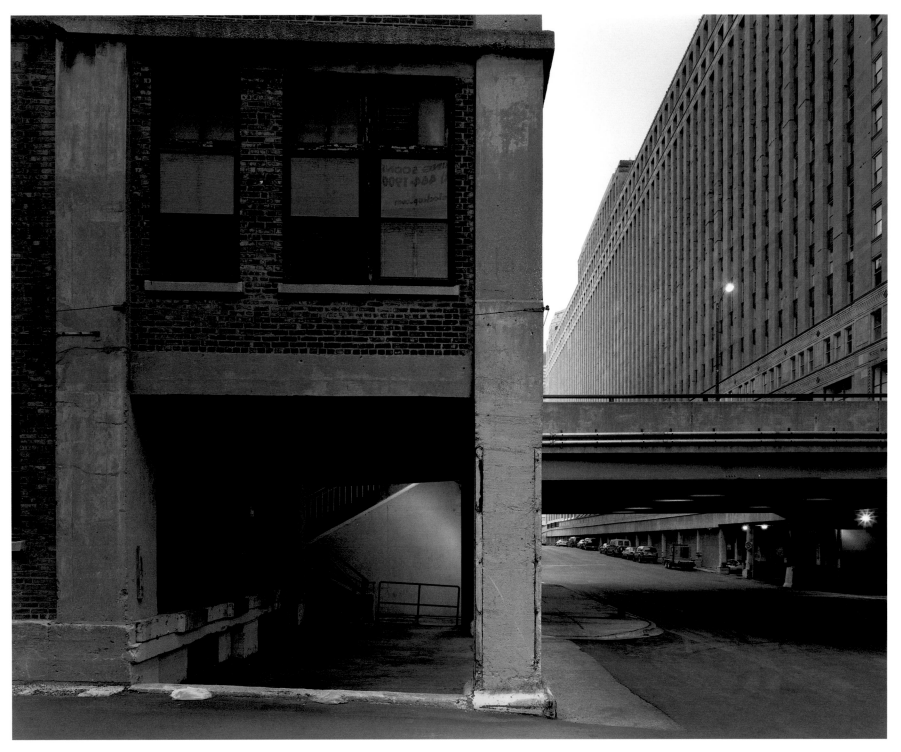

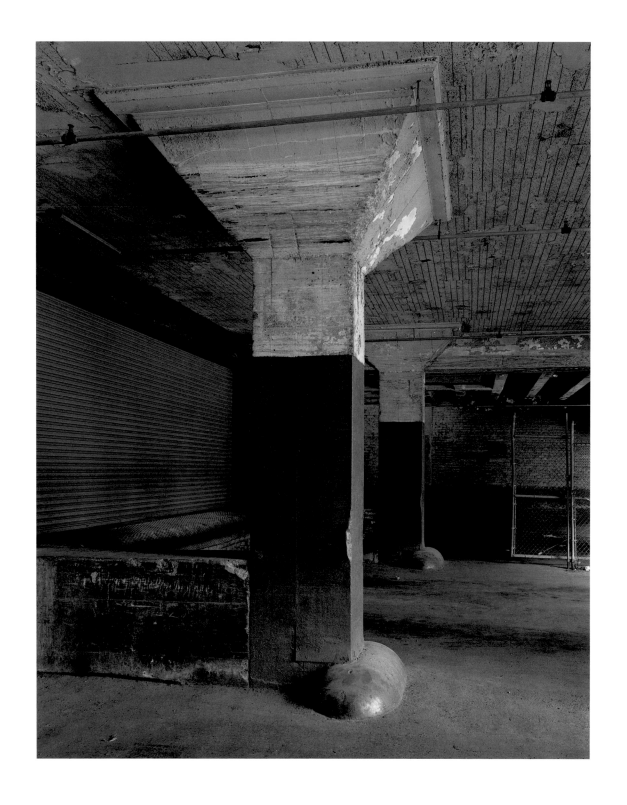

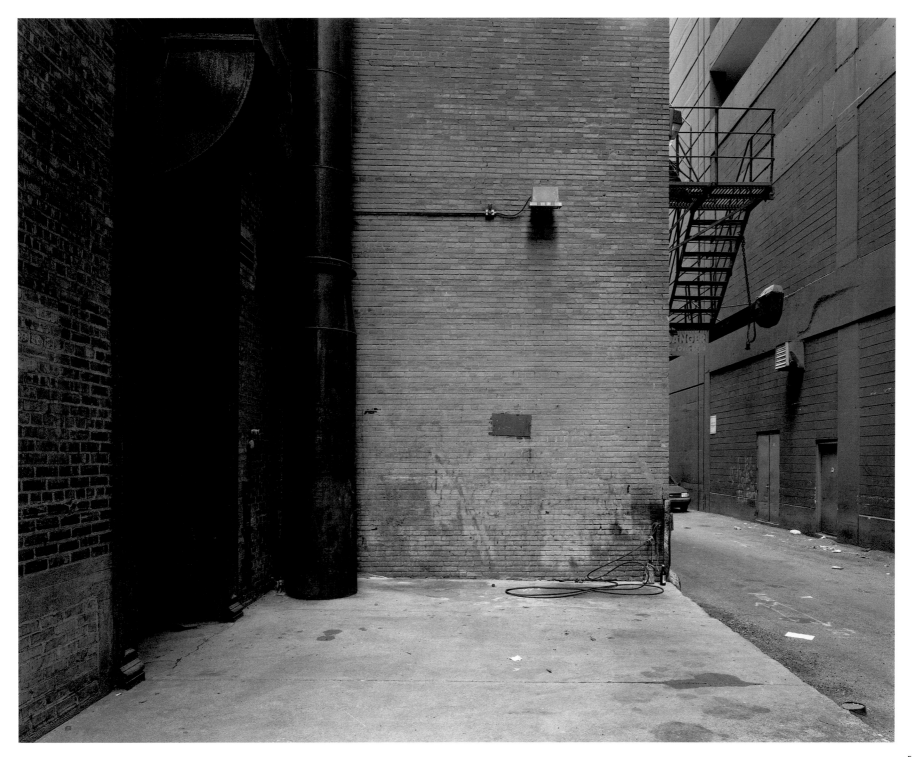

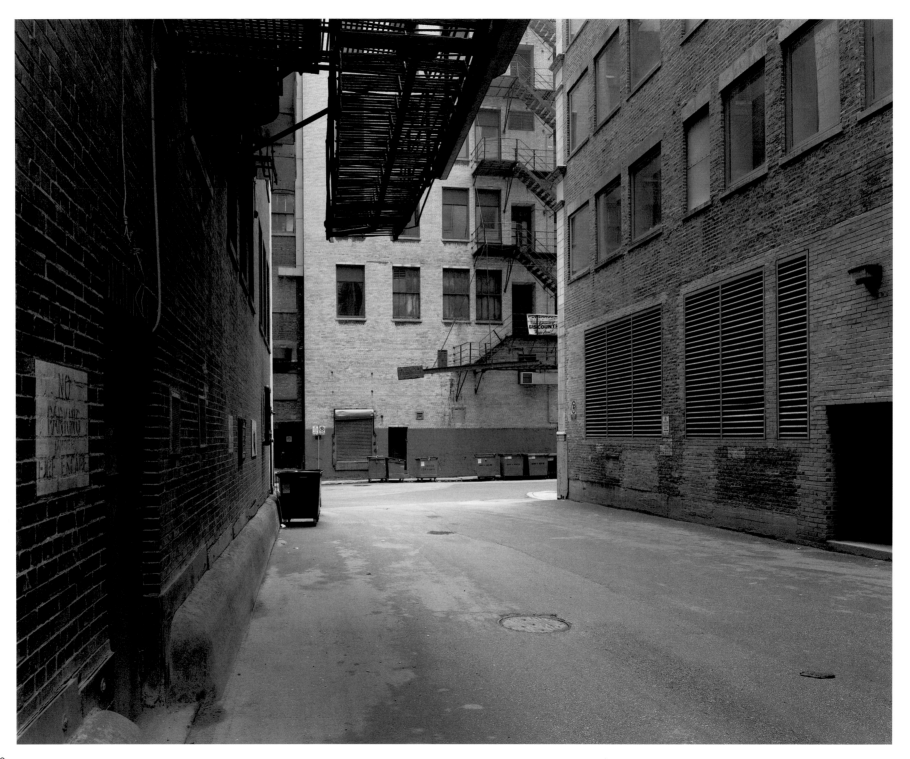

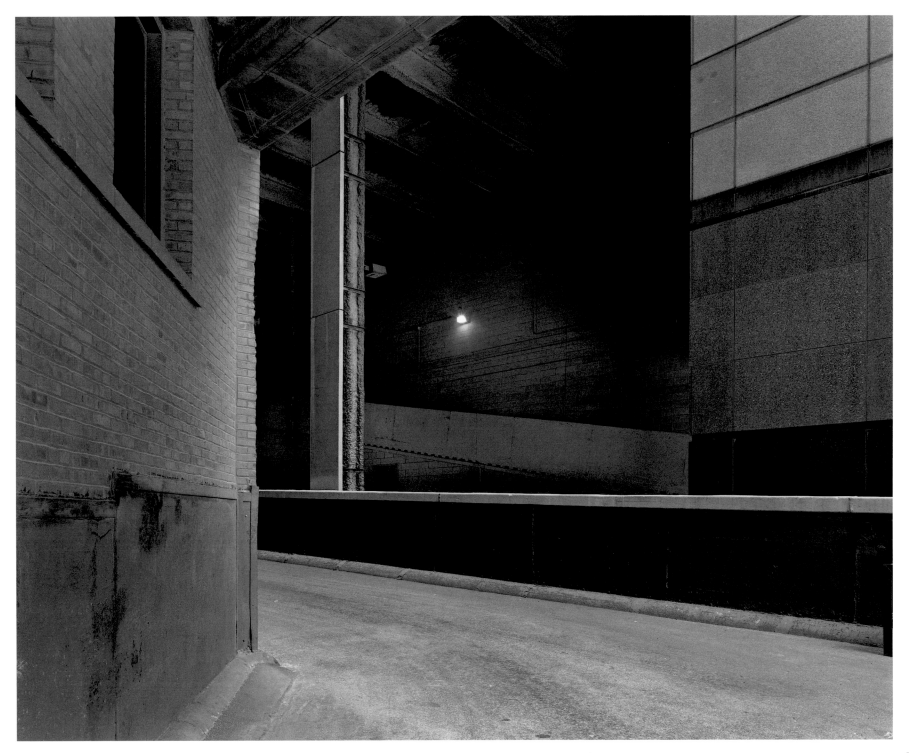

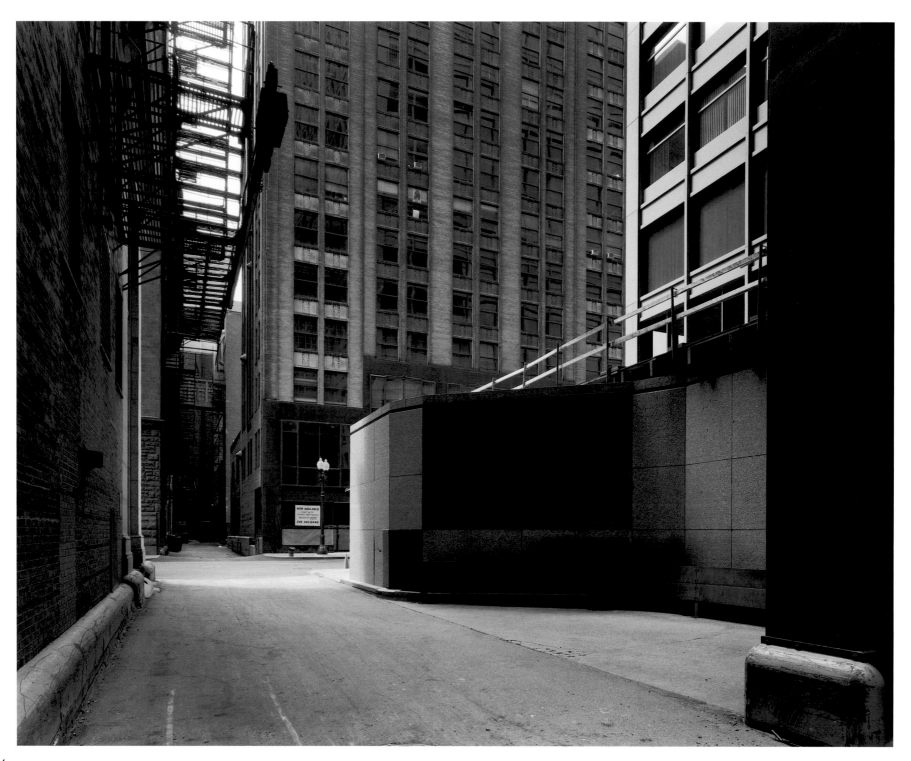

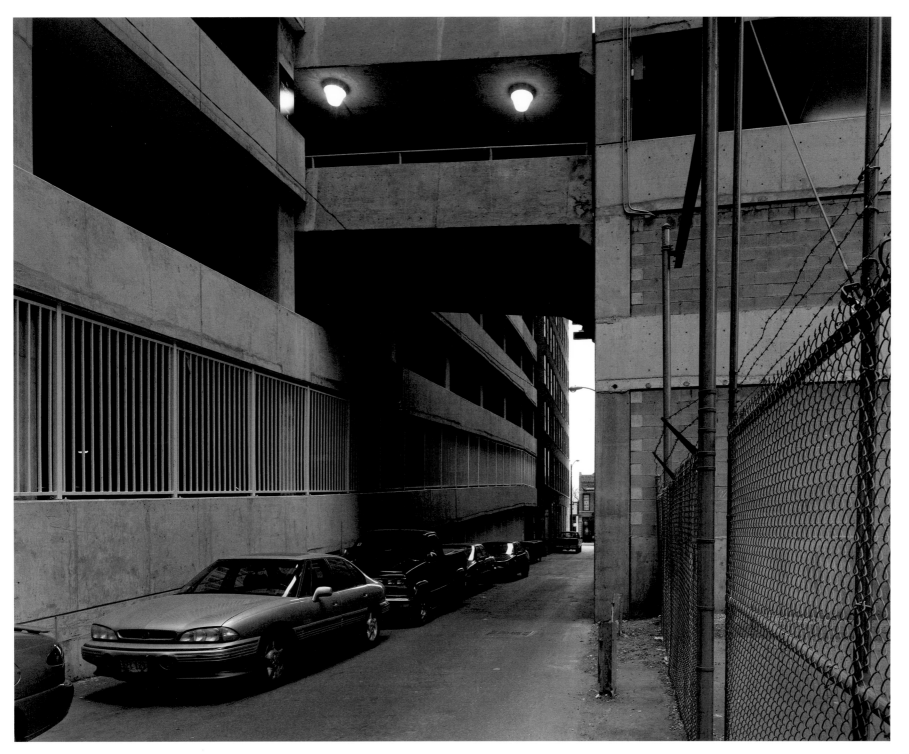

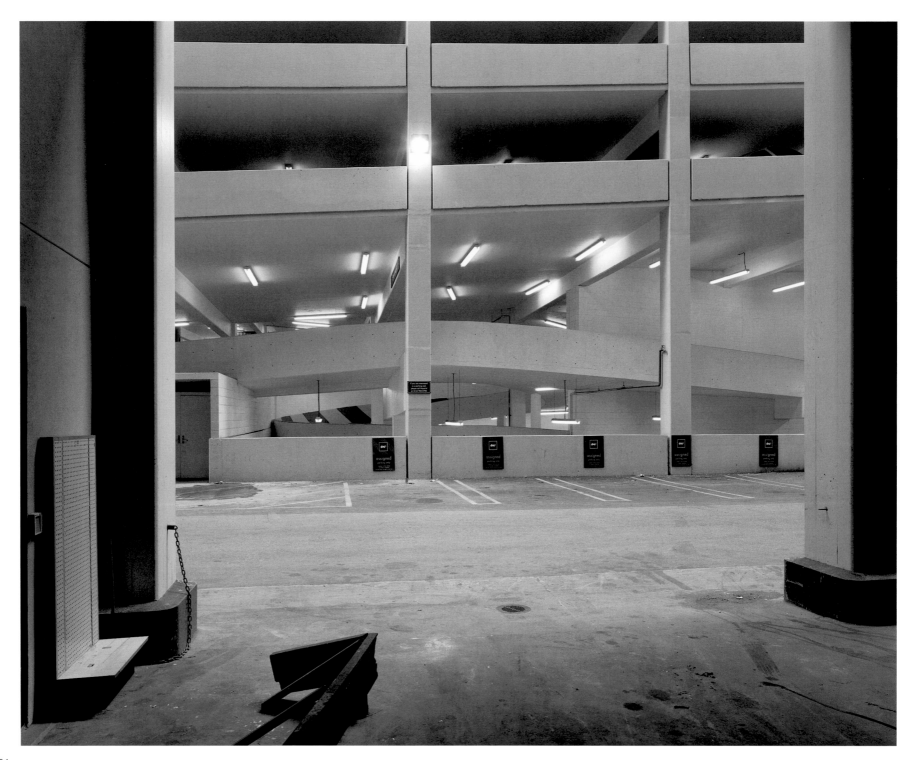

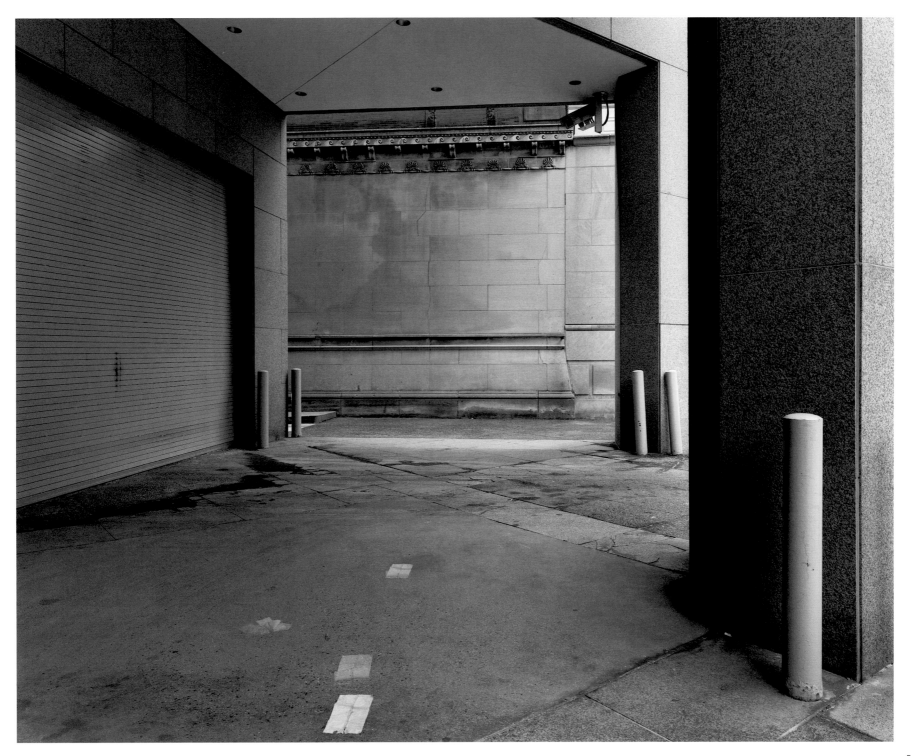

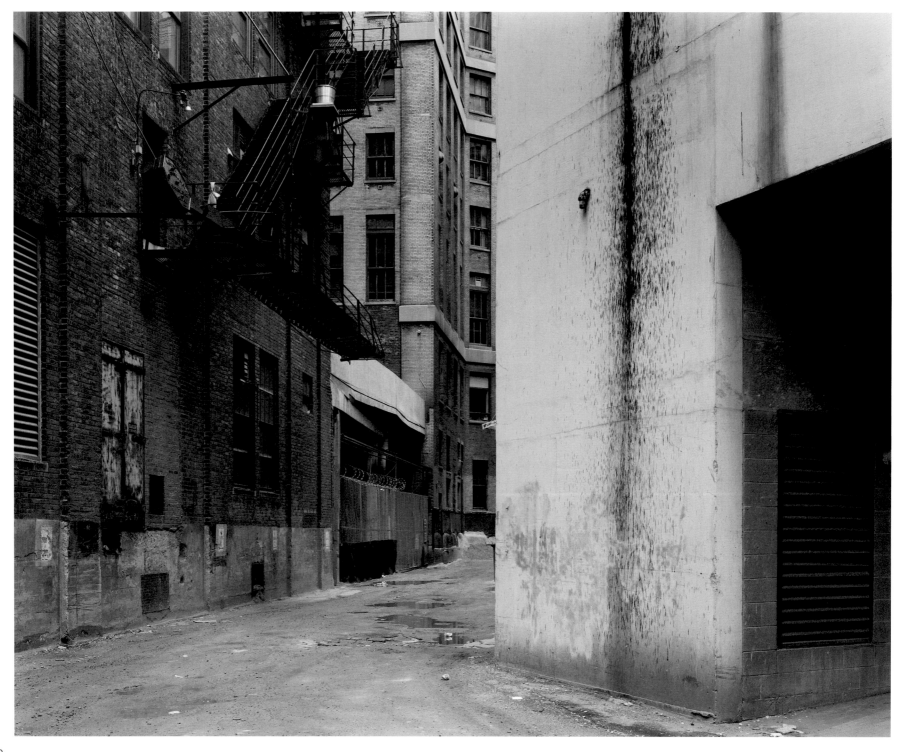

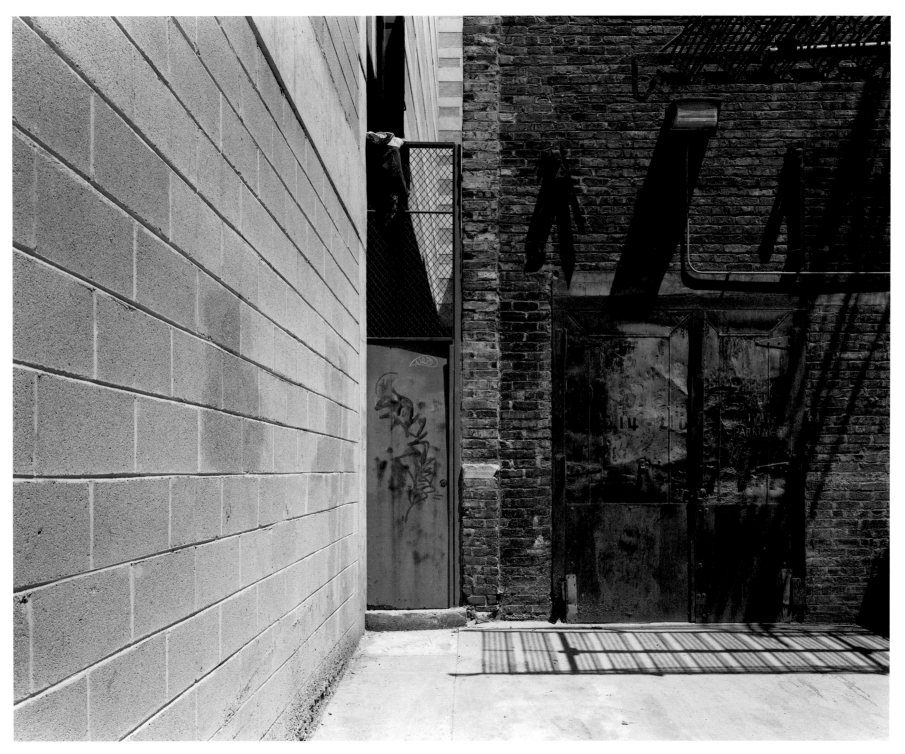

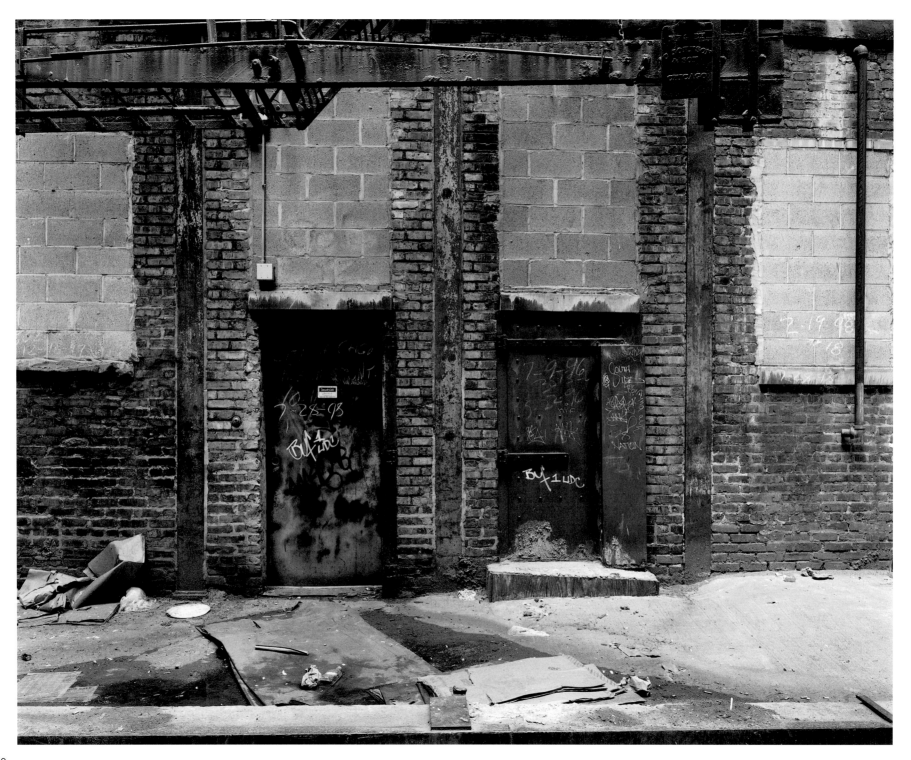

60

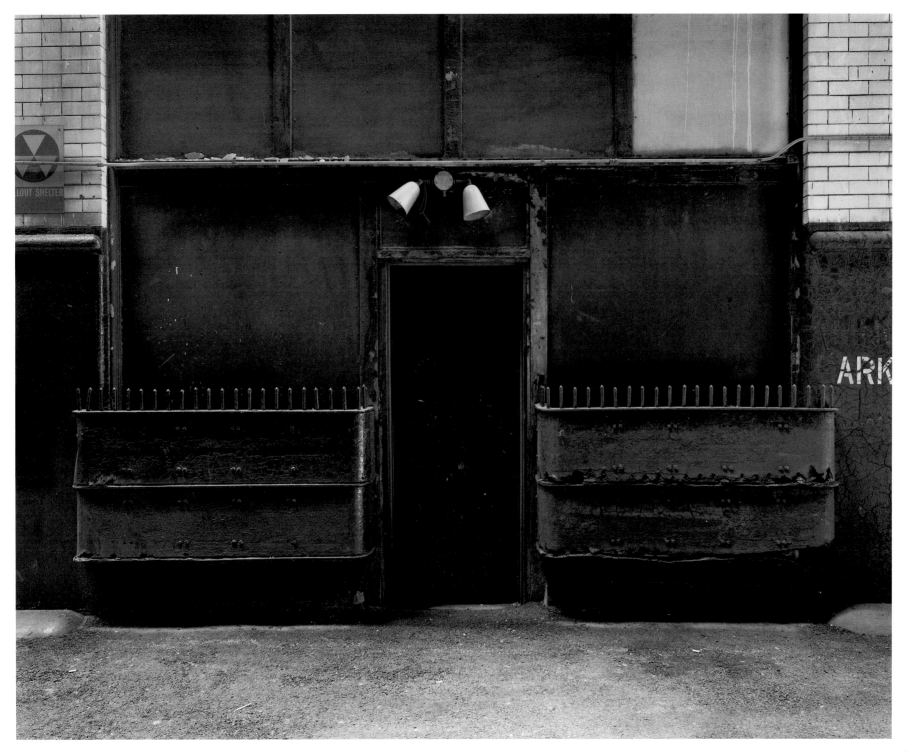

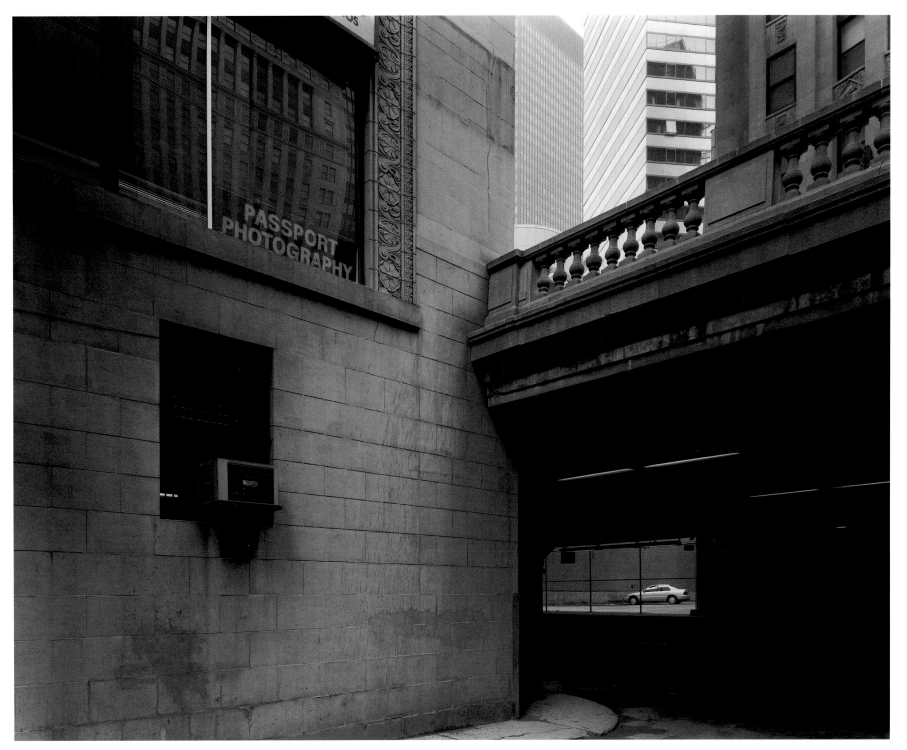

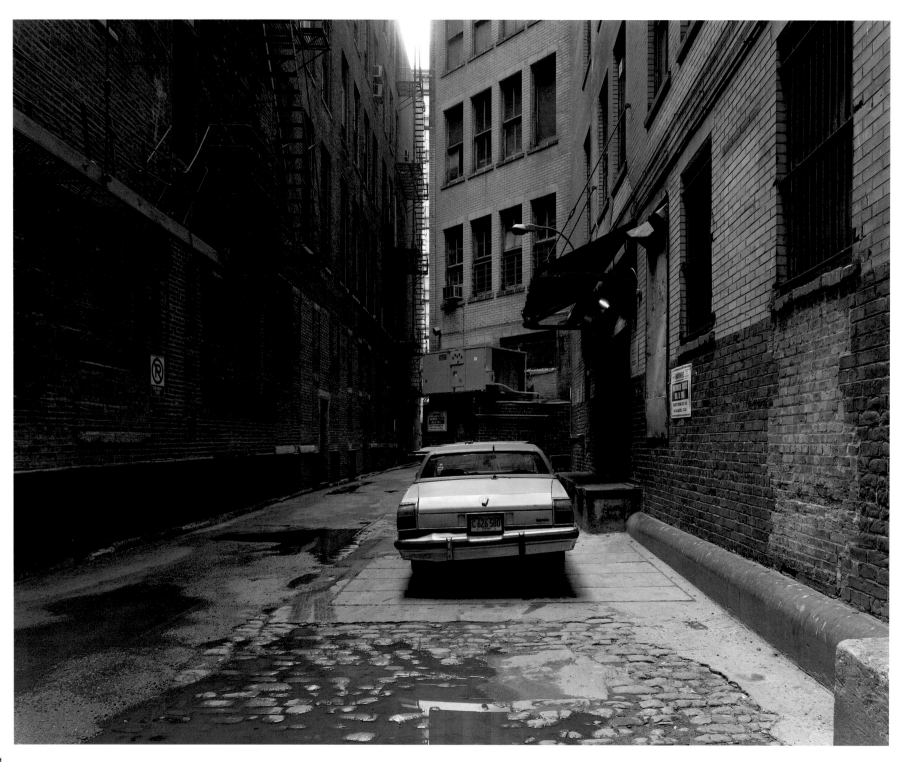

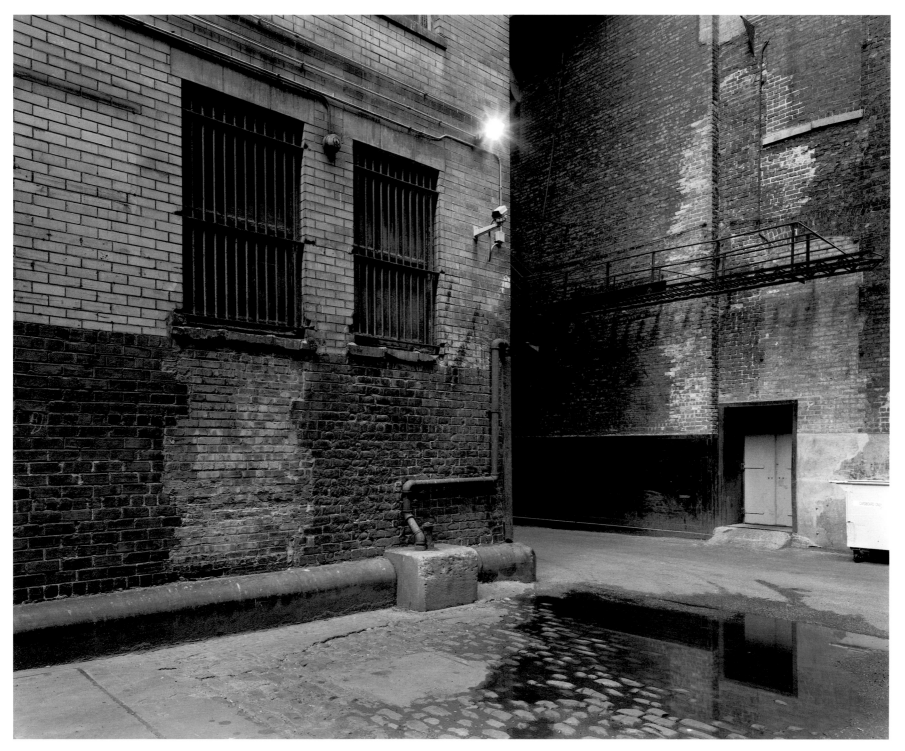

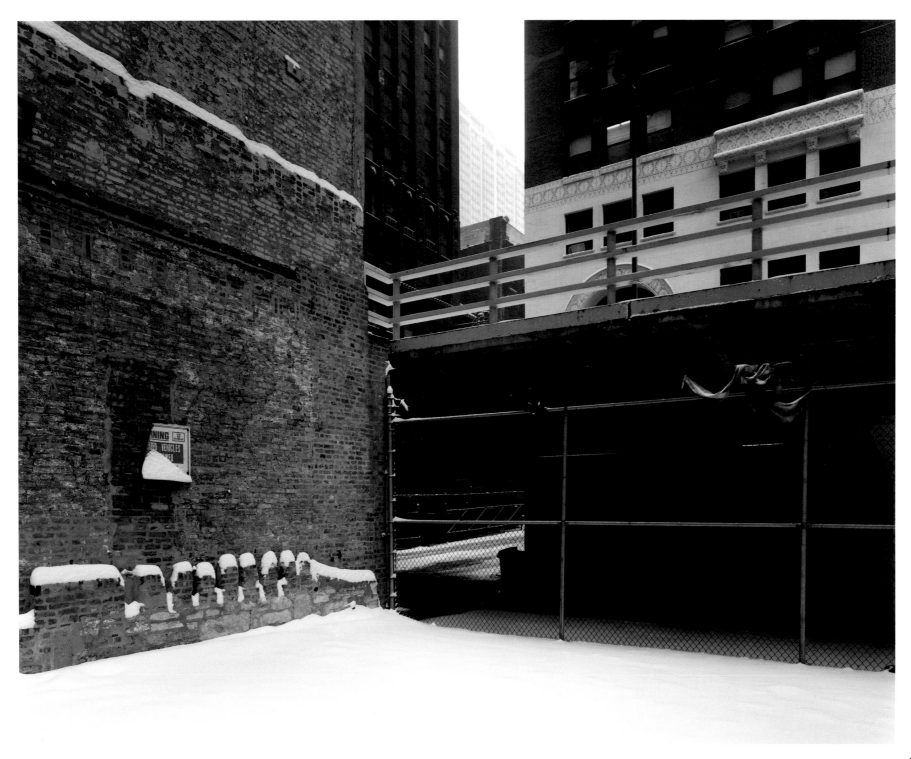

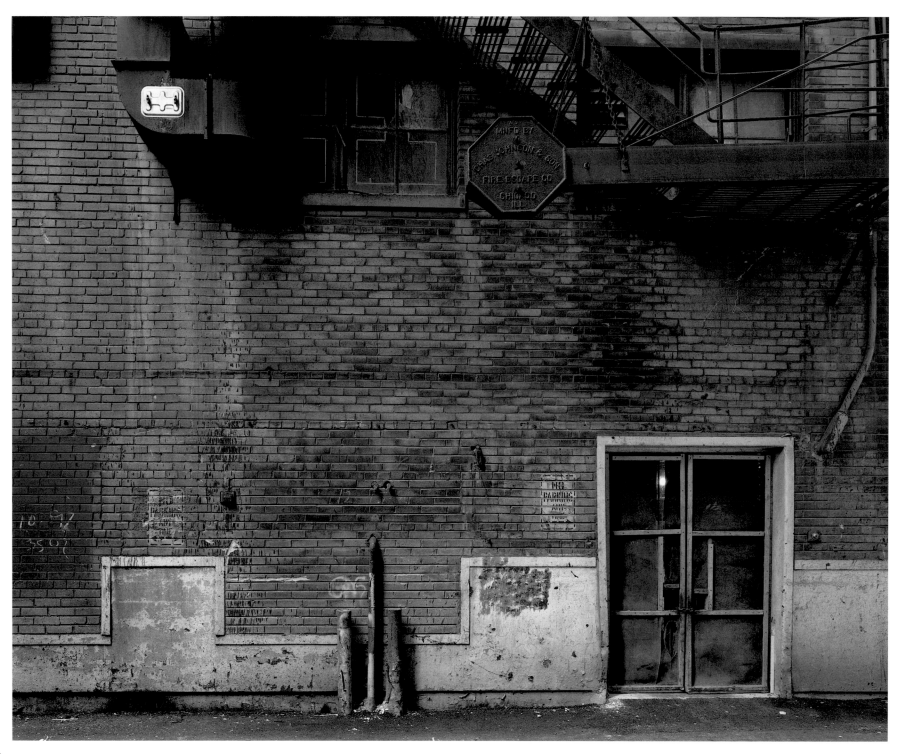

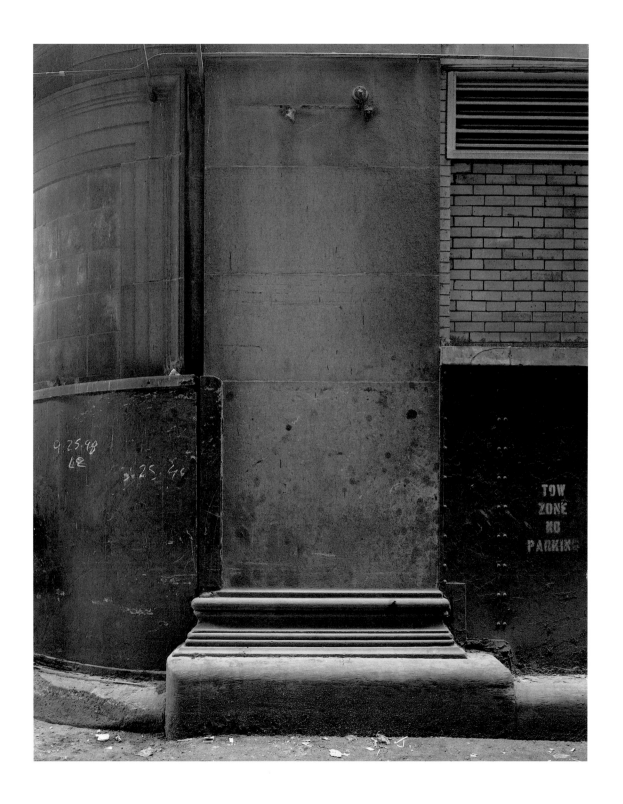

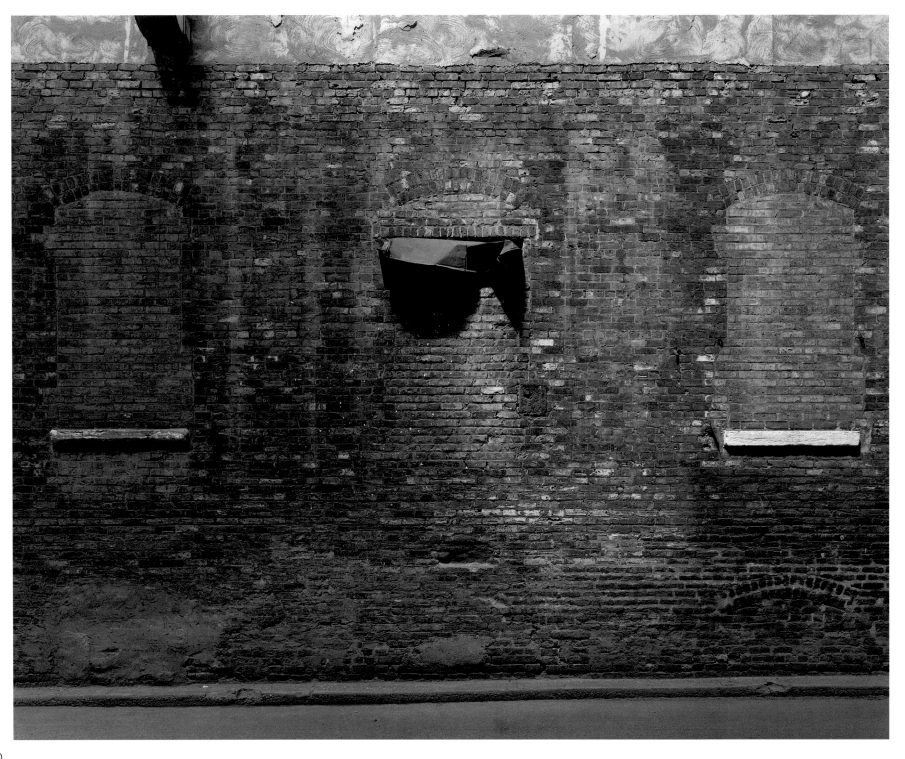

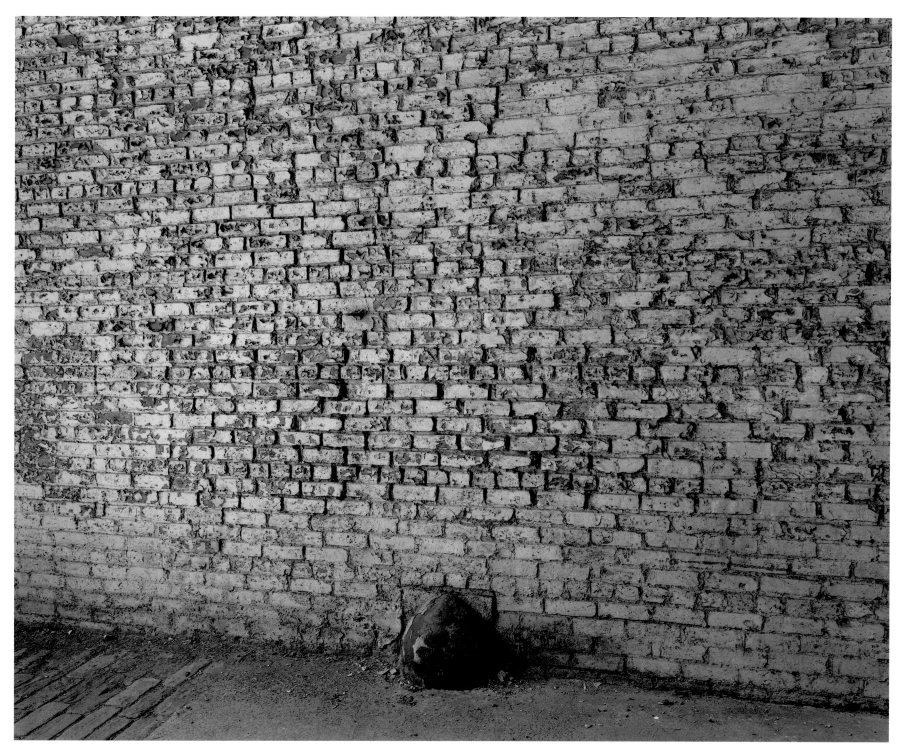

ncorporated during the 1830s out of the ruins of Fort Dearborn, the fur, grain, and real estate traders who built Chicago had no conflicted emotions about cities. Anti-urbanism of the Jeffersonian, Emersonian, or Thoreauian variety never took hold in Chicago where the quintessentially human activity of politics and business was conducted unapologetically right out in the open. In less than twenty years after the Great Fire of 1871, the city's rebuilt downtown had distilled all American ambition into something irreducible. The contemporary architectural critic, Montgomery Schuyler, came closest to defining what it was like to experience Chicago's abundance of tall buildings. He wrote of Burnham and Root's Monadnock Building (1889) that it was like seeing "the thing itself."

The Monadnock is a sixteen-story office building, supported by masonry walls fifteen feet thick. Clad in dark brick with no ornamentation to inter-

Bob Thall, Monadnock Building, 1987
(for the Canadian Centre for Architecture).

rupt the monolithic verticality, nor a steel-frame to lighten the load, the building is a colossus dominating the street. John Wellborn Root, the Monadnock's designer, thought that the building's formal austerity most accurately expressed the spirit of "modern business life." Joined by other massive, practical structures built one next to the other, Chicago's dense downtown grid expressed the real business of America. By all accounts the effect was intoxicating.

During the 1880s and 90s tall office blocks went up in bunches, as many as four to a standard three-acre block. The scale of a person to a building was changed forever. While later buildings certainly got taller and sleeker, it was the initial shock of structures three-to-six times as vast as the existing urban norm that earned the skyscraper its instant status. The unprecedented height and mountainous mass overwhelmed the pedestrians who walked the new city streets and the office workers who toiled above them in the "cliffs." In *The Cliff Dwellers* (1893), Henry Blake Fuller tried to capture the agitating effect of moving on the bottom of the city's many "canyons":

> Each of these canyons is closed in by a long frontage
> of towering cliffs, and these soaring walls of brick and
> limestone and granite rise higher and higher with each
> succeeding year, according as the work of erosion at

their bases goes onward—the work of that seething

flood of arts, carriages, omnibuses, cabs, cars,

messengers, shoppers, clerks, and capitalists, which

surges with increasing violence.

As the buildings got taller, Fuller observed, the streets got deeper "until some of the leading avenues of activity promise soon to become little more than mere obscure trails half lost between the bases of perpendicular precipices." Fuller tried to write about Chicago's gigantism as naturalistically as John Wesley Powell wrote about the Grand Canyon and Colorado River.

His contemporary Frank Norris took another approach in *The Pit* (1903): "The lighted office buildings, the murk of the rain, the haze of light in the heavens, and raised against it the pile of the Board of Trade Building, black, grave, monolithic, crouching on its foundations, like a monstrous sphinx with blind eyes, silent, grave, crouching there without a sound, without sign of life under the night and the drifting veil of rain." The experience of "the thing itself" was simply beyond geological or historical analogy, too abstract for conventional prose. Norris again: "On either side of the vista in converging lines stretched the blazing office buildings. But over the end of the street the lead-colored sky was rifted a little. A long, faint bar of light stretched across the prospect, and silhouetted against this rose a somber mass, unbroken by

any lights, rearing a black and formidable facade against the blur of light behind it."

Even Theodore Dreiser finally ran out of words to name the force that tossed his characters around. He wrote that Chicago's "entire metropolitan center possessed a high and mighty air calculated to overawe and abash." The "vast buildings" communicated raw "power and force" (*Sister Carrie,* 1900). And that's about the closest he ever came to understanding the compelling power of a great American city.

At the beginning of the twenty-first century what is recoverable from that city whose original effect was inexpressible? What was Chicago like when the old was new, when the past was present and experience so raw that it seemed beyond language?

The answer lies sedimented in the detritus left behind in the alleys of the thirty-nine block downtown where sheer walls of concrete and brick rise up from pocked asphalt barely two lanes wide. There are no setbacks, no windows, no variation; the buildings on either side weigh you down. These are streets where junk is barnacled to walls spray-painted with graffiti, chalked by rat exterminators, snaked by electrical conduits, pocked by junction boxes, and jaundiced by sulphur-vapor lamps.

Behind the old wholesale and manufacturing district near Wells Street there are abandoned loading docks where the tanned and dyed leather was

delivered in the morning and the finished shoes were carted off at night. A broken sign and a lintel over a bricked-over doorway point the way to a fourth floor loft where acres of fabric were sewn into cloaks and suits. Steps that now lead nowhere were once the preferred entrance to bars, brothels, and gambling joints.

But the historian is mostly frustrated here. More is lost than found. Gone without a trace are movie theaters, food shops, restaurants, bars, jazz clubs, pool halls. Names synonymous with the daily life of the city, such as Fritzel's, Kranz's, Gaper's, Bensinger, and Plitt, are now as exotic as extinct birds. Thousands of independent businesses are absent. A third of the Loop has been completely rebuilt twice since the Chicago Fire and blocks that once supported twenty buildings now have only one. Yet with all that has been lost the alleys have strangely distilled their essence into something timeless.

In an atmosphere of crabbed views and narrow sun-dialed light we notice the beauty of a steel cruciform brace supporting a brick wall herniated with age. Fire escapes, security gratings, and chain-link fencing utterly indifferent to aesthetic refinement perfectly rake the shadows on the surface of the imperfect walls. Such unexpected refinement is what captured Saul Bellow's attention when he looked west between the El pillars to see the sunset's "scarlet afterglow." Or when he described how the "tremendous trusses of the unfinished skyscraper turned black, the hollow interior filled with thousands

of electric points resembling champagne bubbles." He knows that "the completed building would never be so beautiful" (*Humboldt's Gift,* 1973).

The alleys are full of such surprises. Here are odd, looming spaces of the kind that De Chirico liked to paint and Kafka minutely described; Weegee stalked the stars sneaking out of back doors; Brassai and Kertesz shot the shadows between buildings; Atget rendered the silence of emptied spaces. To the voids of the frantic city, photographers, writers, and painters have developed a powerful attraction. But they will never exhaust their possibilities.

For more than thirty years Bob Thall has been lugging his tripod and heavy view camera downtown. He has assembled a record of Chicago past and present that teases the memory and tests the eye. His studied portraits of long-abandoned theaters, teetering walkways, and empty streets are beautiful in their austerity. With an impassioned curiosity for primary experience Thall makes us look again at just some of what we daily overlook. Unlike Garry Winogrand and Henri Cartier-Bresson who shot people in extraordinary moments with a light camera, fast film, and a sense of ironic detachment, people are absent from Thall's slow, watchful photographs. Yet their strong presence is felt in the ordinary, unpretty things which through necessity or carelessness they leave behind. Bob Thall has watched attentively as a significant portion of historic downtown Chicago disappeared through urban

renewal, commercial development, and neglect until only the alleys were left fundamentally undisturbed.

In these patient un-peopled photographs of the narrowed backsides of buildings we can re-experience history not as a shocking sudden thing but slowed down and minutely observable in all the random fragments left on pavement and walls. What we have here are purposefully un-cinematic, rigorously undramatic photographs whose power resides in their unwavering attention to detail. Bob Thall takes portraits of the city's turned-away side, the way a novelist portrays a pocked face or an awkward gait not to gawk or evoke cheap sentiment but to depict the whole human spectacle piece by piece in all its fresh particularity. He reveals in these hauntingly irregular slivers of space at the very heart of Chicago's grid a utilitarian and wickedly compelling world of its own. All this brilliant variety, right under our noses all along, is now exposed.

**ABOUT THE AUTHOR
AND ESSAYIST**

Bob Thall was born and raised in Chicago. He received his B.A. and M.F.A. degrees in photography at the University of Illinois Chicago, and in 1976 joined the faculty of Columbia College Chicago where he is now a professor of photography and chairman of the photography department. Mr. Thall was a principal photographer on the National Road and Court House projects, and in 1998 he was awarded a John Simon Guggenheim Memorial Foundation Fellowship for Photography. His photographs are in the permanent collections of the Art Institute of Chicago, the Canadian Centre for Architecture in Montreal, the Getty Center for the History of Art and the Humanities in Los Angeles, the Library of Congress in Washington, D.C., the Museum of Contemporary Photography in Chicago, the Museum of Fine Arts in Houston, and the Museum of Modern Art in New York City, among others. He is the author of *The Perfect City* (Johns Hopkins, 1994), which was accompanied by a one-person show at the Art Institute of Chicago, and *The New American Village* (Johns Hopkins, 1999), which was accompanied by a one-person show at the Museum of Contemporary Photography in Chicago.

Ross Miller was born in Brooklyn, New York, and grew up in and around New York City. He received an A.B., with high honors, from the University of Michigan and completed an M.A. and Ph.D., with highest honors, from Cornell University. Currently a professor of English and comparative literature at the University of Connecticut, Ross Miller has been a visiting professor at Yale University, Wesleyan College, Trinity College, UCLA, and Ohio State University. He has been awarded an N.E.H. senior research fellowship, a Presidential Teacher award (White House Commission on Presidential Scholars), and three grants from the Graham Foundation for Advanced Studies in the Fine Arts, among other honors. Miller was a contributing editor (1990–94) for *Progressive Architecture* and a senior scholar and director of the Chicago Institute for Architecture and Urbanism (1989–93). He has written for the *Washington Post*, *Wall Street Journal*, *Los Angeles Times*, *Chicago Tribune*, and other scholarly publications, and he is the author of *American Apocalypse: The Great Fire and the Myth of Chicago* (Chicago, 1990; Illinois, 2000) and *Here's the Deal: The Buying and Selling of a Great American City* (Knopf, 1996; Northwestern, 2002).

THE CENTER FOR AMERICAN PLACES is a tax-exempt 501(c)(3) nonprofit organization, founded in 1990, whose educational mission is to enhance the public's understanding of, and appreciation for, the natural and built environment. It is guided by the belief that books provide an indispensible foundation for comprehending—and caring for—the places where we live, work, and explore. Books live. Books endure. Books make a difference. Books are gifts to civilization.

With offices in New Mexico and Virginia, Center editors bring to publication 20–25 books per year under the Center's own imprint or in association with its publishing partners. The Center is also engaged in numerous other programs that emphasize the interpretation of *place* through art, literature, scholarship, exhibitions, and field research. The Center's Cotton Mather Library in Arthur, Nebraska, its Martha A. Strawn Photographic Library in Davidson, North Carolina, and a 10-acre reserve along the Santa Fe River in Florida are available as retreats upon request.

The Center strives every day to make a difference through books, research, and education. For more information, please send inquiries to P. O. Box 23225, Santa Fe, NM 87502, U.S.A. or visit the Center's Web site (*www.americanplaces.org*).

ABOUT THE BOOK:

The text for *City Spaces* was set in Granjon with Futura display. The paper is acid-free Silk Mediaprint paper, 150 gsm weight. The tritone separations, printing, and binding were professionally rendered by Oddi Printing Ltd., of Reykjavik, Iceland.

FOR THE CENTER FOR AMERICAN PLACES:

George F. Thompson, president and publisher

Randall B. Jones, editor and publishing liaison

David Skolkin, designer and typesetter

Charles B. Gershwin, production coordinator